WALTER POTTER'S
CURIOUS WORLD
of TAXIDERMY

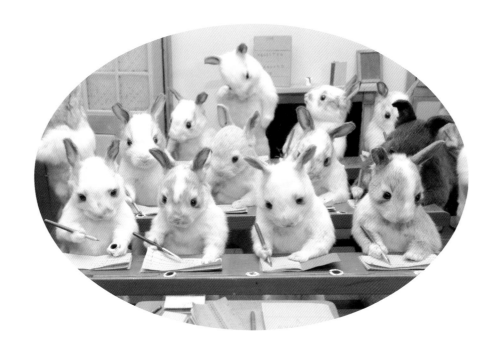

DR PAT MORRIS
WITH JOANNA EBENSTEIN

FOREWORD BY SIR PETER BLAKE

CONSTABLE

Constable & Robinson Ltd
55–56 Russell Square
London WC1B 4HP
www.constablerobinson.com

First published in the UK in 2008 by MPM Publishing

This substantially revised edition with new photographs first published in the UK in 2013 by Constable, an imprint of Constable & Robinson Ltd

Copyright © P.A. Morris, 2013

The right of P. A. Morris to be identified as the author of this work has been asserted by him in accordance with the Copyright, Designs and Patents Act 1988.

A CIP catalogue record for this book is available from the British Library.

ISBN: 978-1-4721-0950-7

1 3 5 7 9 10 8 6 4 2

www.walterpottertaxidermy.com

❧ CONTENTS ❧

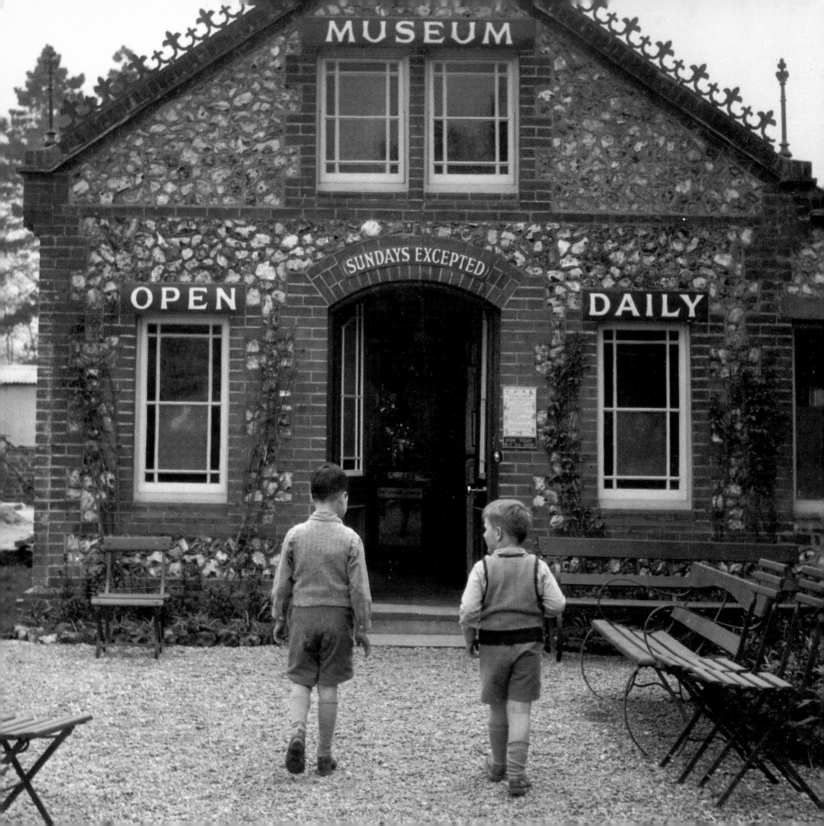

✎ FOREWORD ✎

In 2010, legendary pop artist Sir Peter Blake co-curated an exhibition in London at Primrose Hill's Museum of Everything. This was the first time a number of pieces by Victorian taxidermist Walter Potter had been exhibited together since the collection – which had been on view for nearly 150 years – was broken up at auction in 2003. The exhibition drew over 30,000 visitors in six weeks and attracted enthusiastic coverage in the press.

One day in the late 1950s, when I was about fifteen, I was on a cycling holiday with my father. We stopped at a pub in the village of Bramber, noticed the little museum across the road and, inquisitive, decided we should visit it. That was sixty-five years ago, but I still remember walking into a space like a dusty boy-scout hut, filled with wondrous things.

I didn't ever go back to Bramber and some years later read that Mr Potter's Museum of Curiosity was to be sold. After briefly entertaining the idea of trying to buy it, I realized I would have nowhere to install it and, more pertinently, I had no money. I didn't see the museum at its new homes in either Brighton or Arundel, but caught up with it once more in Cornwall, by coincidence just before I read again that its contents were for sale.

Damien Hirst was rumoured to have offered one million pounds for the entire collection, and that would have been perfect if it had been installed at his planned museum and gallery at Toddington, but it wasn't to be.

So on Tuesday September 23rd 2003, I arrived at Jamaica Inn for the two-day auction. I was surprised that Damien wasn't there, but recognized old friends James Birch the art dealer and the photographer David Bailey. I was told recently that Harry Hill was also there.

My plan was to try to buy enough pieces to recreate, within my own collection, a small version of Mr Potter's Museum of Curiosity. I allocated £10,000, which I wouldn't go beyond; I think I eventually spent £10,100.

Lot 13 was *The Death & Burial of Cock Robin*. As Mr Potter's first tableau, and arguably the best item in the auction, this sold for £20,000 and my hopes of getting very much were severely dented. Fate was perhaps on my side though, as during bidding on *The House That Jack Built*, a car backfired outside, sounding like gunshot, and bidding stopped at my offer of £3,200; so I acquired what I consider Mr Potter's second-best tableau. Further items were added to my collection, including *The Babes in the Wood*. I have made my own version of Mr Potter's museum and ten years after the auction still enjoy it very much.

Peter Blake

1 May 2013, London

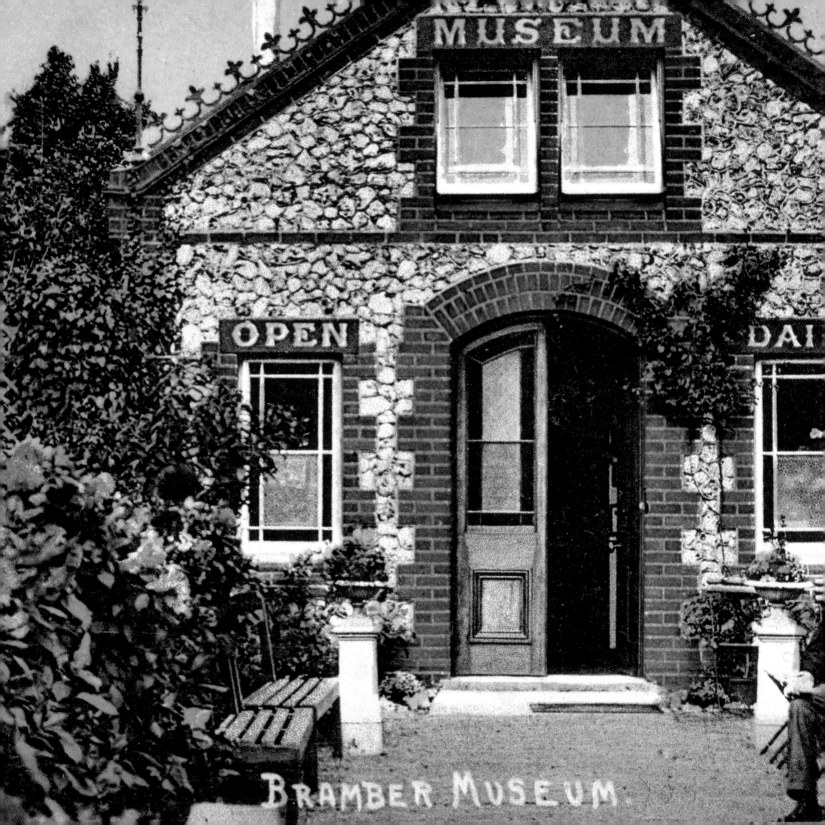

MUSEUM

OPEN

DAI

BRAMBER MUSEUM.

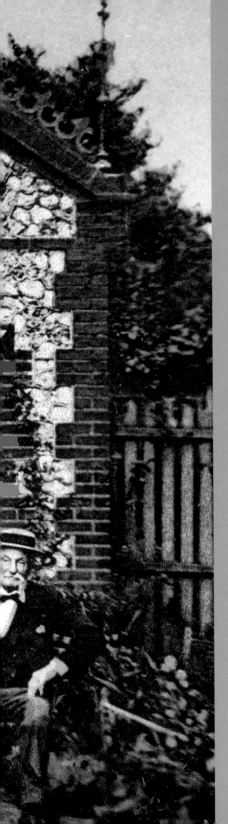

THE LIFE & TIMES OF

WALTER POTTER

BIOGRAPHY

CAREER

INSPIRATION

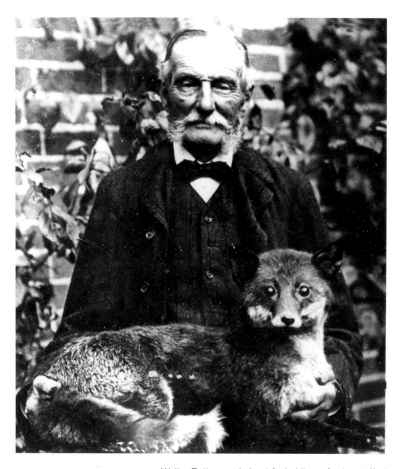

Walter Potter aged about 80 holding a fox he stuffed.

Oil on canvas portrait of Walter Potter when he was about seventy-five, by Bernard Lucas R. A. This used to hang on a beam above the second table in the middle of the old museum at Bramber.

Walter Potter was born on 2 July 1835. He spent all of his long life in the West Sussex village of Bramber, where he still rests in the village churchyard. A distinctive and bewhiskered man, he dressed in a three-piece suit, with a silver watch chain dangling from his waistcoat pocket and a white straw boater hat in summer. He always wore a top hat to church on Sundays, where he served as a churchwarden for thirty years and a parish overseer for even longer. In later life he spent his leisure time carefully tending his garden, where he worked long hours and grew flowers for sale.

Walter left school at the age of fourteen to help his father, who became the publican at the village inn, at that time called the White Lion. Young Walter, initially employed as a labourer, was also a keen naturalist who kept tame jackdaws and taught pet starlings to speak. In his spare time, Walter learned to preserve birds and animals and began a small collection of stuffed animals, adding new specimens as they became available. He was allocated space in a small attic in the White Lion's stableyard and later was given the use of a small outbuilding to house his burgeoning collection.

Walter Potter's first major creation was his tableau depicting *The Death & Burial of Cock Robin*. The inspiration for this had come from the illustrations in a popular book of nursery rhymes that had been given to his younger sister Jane in 1841, when she was four years old. Potter began his great masterpiece in 1854, aged nineteen, and it took him seven years to build in his spare time. It was finished in 1861, having provided an amusing hobby and also a constructive repository for large numbers of his spare stuffed birds. That tableau became his most famous creation, and perhaps the

most widely known single item of Victorian taxidermy ever made.

In 1861, the brewers who owned the inn generously provided a small summerhouse across the yard, recognising the value of Potter's work in bringing large numbers of thirsty customers to the otherwise undistinguished village of Bramber. Later, the expanding collection was moved to another building, where it remained for fourteen years, before moving to a specially-built museum on land next to the inn. It opened there in 1880, about the time that the White Lion was enlarged and renamed the Castle Hotel.

The new building was now officially designated 'Museum' by a prominent sign under the eaves. Constructed in a style highly typical of that part of Sussex, built of local flints with red brick at the corners and around the windows, it was set in a pretty little garden, where it and its contents remained almost unchanged for nearly a hundred years.

Potter's fame continued to spread and visitors to the inn would commission him to preserve their pets and various dead animals that they found locally. There were bigger and better taxidermy businesses in Brighton and elsewhere in rural Sussex, but dead animals need urgent attention, especially in summer, and transport was slow. For the people around Bramber, Potter was the obvious local taxidermy practitioner to whom they would turn in times of need. Consequently he obtained sufficient commissions, supplemented by admission charges at the museum, to earn his keep and care for his family.

Walter married a local girl, Ann Stringer Muzzell, in the summer of 1867, when he was thirty-one. In due course,

OLD DAME TROT AND HER COMICAL CAT.

A parrot Trot bought,
"Twould please Puss she thought,
And serve to amuse them for hours;
Quite pleased and content,
Her steps home she bent,
And found the Cat watering the flowers.

Dame Trot loved a joke,
So mirth to provoke,
An owl wheeled about in a barrow:
Her Cat cried " Away,
No longer here stay,
Or I'll shoot him dead with an arrow."

Several of Potter's creations were inspired by nursery rhyme books like this one, belonging to his younger sister.

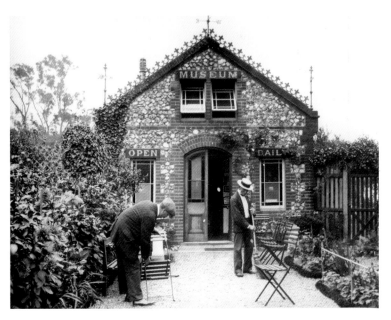

Walter Potter (on the right) tending the Bramber Museum garden, about 1900.

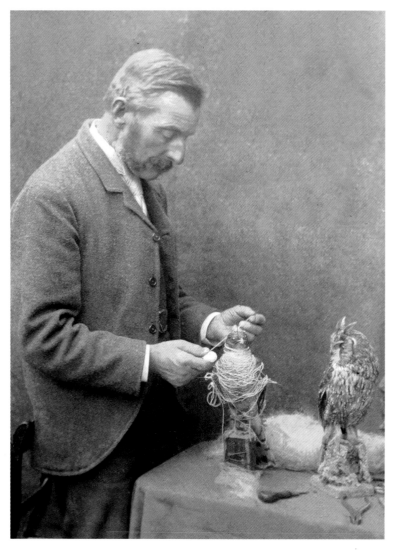

(above) Walter Potter in 1880, winding cotton threads round a mounted sparrowhawk to hold its feathers in place while the skin dried. A bundle of woodwool is visible, from which its false body would have been made.

(below) Three different versions of Walter Potter's small printed trade labels.

Ann produced a son (Walter John Potter, 1869–1928), then two daughters, Annie (who died in 1893, aged seventeen) and Minnie (1877–1965).

The Potter family lived together in Bramber Villa, the four-bedroomed house that was adjacent to the museum. Each evening, Walter would close the museum for the night, then walk next door to the inn for his regular pint of beer. At the bar, he had time to observe his fellow drinkers, doubtless providing ideas for his anthropomorphic animal tableaux. There would also have been plenty of opportunity to discuss local natural history, such as ferreting for rabbits and tales of rats carrying away chicken's eggs, all of which would later feature in Walter's exhibits. No doubt the pub would also have been part of the local grapevine that resulted in Walter acquiring such a diverse assortment of curios from places both local and faraway. It is easy to imagine local workmen bringing Walter many of the bizarre bits and pieces he added to his collection such as the last village candle lamp or a giant coypu rat trapped on the local river.

At this time, Walter concentrated on creating his famous 'anthropomorphic tableaux', depicting groups of stuffed animals posed as though they were tiny humans. He appears to have been inspired by the illustrations in a small children's book, *Peter Parley's Present* (published about 1840). His focus on such novelty taxidermy may also have been inspired by a visit as a sixteen-year-old to the Great Exhibition of 1851. Children were encouraged to go to the newly-erected Crystal Palace and marvel at the exhibits there, among them German taxidermist Hermann Ploucquet's tableaux recreating some famous eighteenth-century illustrations of the story of Reynard the Fox. Ploucquet also exhibited frogs having

a shave, kittens serving tea and a marten acting as a schoolmaster. Queen Victoria wrote about Ploucquet's exhibits in her diary and pictures of them subsequently appeared in the *Illustrated London News* of 1851 and other publications describing the Great Exhibition.

This particular style of anthropomorphic taxidermy, familiar to Ploucquet's German and Austrian customers, became more widely adopted in Britain after the famous displays at the 1851 Great Exhibition. Walter Potter quickly became the leading British exponent and quite soon taxidermists far and wide were copying the style, most often using frogs and squirrels, as their shape and body proportions most easily lend themselves to imitating humans.

The late nineteenth century was the heyday of fashionable taxidermy. Stuffed birds were particularly prized domestic ornaments and no Victorian parlour was complete without its case of birds or other wildlife. Examples of Potter's work for customers rather than for his own collection do occasionally turn up at auction. Despite the use of homemade arsenical soap (containing white arsenic, chalk and shredded soap) in preserving his specimens, Walter Potter lived to the ripe old age of eighty-three.

Walter Potter was not related to Beatrix Potter, despite their shared interest in anthropomorphic representations of animals. She was born in 1866 and Bramber museum would have been a potential day trip by train from her home in London. However, Beatrix Potter's first book (*The Tale of Peter Rabbit*) was not published until 1902, so although she may well have derived inspiration from Walter Potter's work, the reverse is unlikely.

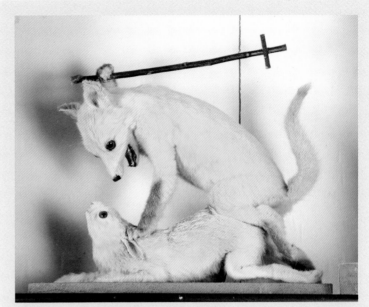

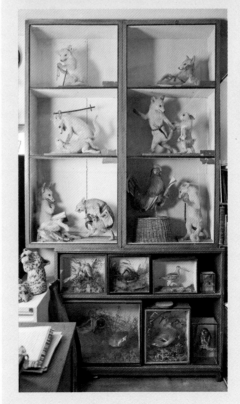

Hermann Ploucquet's work shown at the Great Exhibition in 1851 may have inspired the young Walter Potter. His six tableaux enacting the story of Reynard the Fox (left and detail above, from the author's collection) amused Queen Victoria. The illustration from Goethe's 1846 version of the story (above, right) seems to have provided direct inspiration.

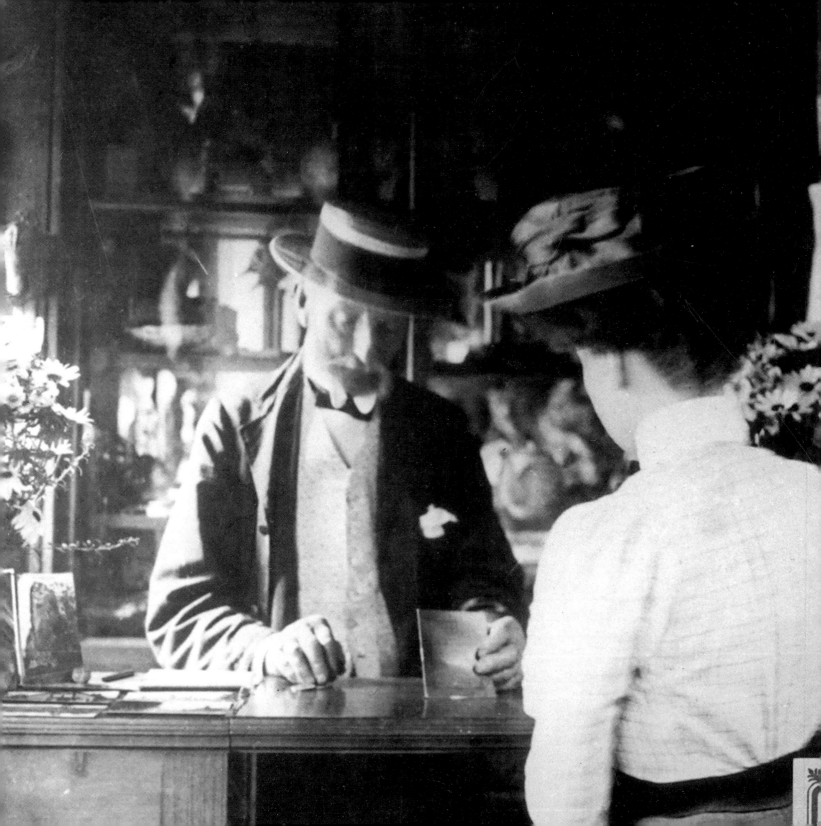

Walter Potter

CHAPTER 2

Walter Potter's

MUSEUM

BRAMBER

BRIGHTON

ARUNDEL

CORNWALL

AUCTION

The old building to the left in the pub yard, which had previously housed the museum, was made into a tea room in 1954, adding to the appeal of a visit to Bramber and providing additional income for the museum.

BRAMBER (1861–1972)

Well into old age, and long after the death of his wife, Walter continued to greet visitors to the museum, which remained open during the First World War. An item in *The People*, (4 January 1914), referred to a 'museum never to be forgotten'. Here it said 'people may fail to recognise in the old gentleman, who is often to be seen seated near the door, a genius who has created a fairyland of nursery rhymes and who, not withstanding his 78 years is as much wrapt up in the tale of Nature as he was some 60 years ago when he started his life's work'.

Walter sadly never finished his last taxidermical scene, *The Squirrels' Court, with Judge and Jury*. In 1914, in the early months of the First World War, he suffered a minor stroke from which he never fully recovered. He died aged eighty-three, on 1 May 1918.

Walter junior, a solicitor's clerk, inherited half his father's estate (valued at £1,189/6/9d, about 50% more than his publican grandfather's estate), but was apparently unwilling to take on responsibility for the museum. His younger sister Minnie inherited and ran the museum with her husband, Edgar Weller Collins, for twenty years or more. Edgar enlarged the collection and produced a new guidebook. As part of his promotional activities, he kept a long wooden box of forty-five magic lantern slides, with which he probably toured locals schools, working men's clubs and similar social gatherings to give illustrated talks about the museum.

During the Second World War the museum remained open at least some of the time, with local schoolchildren among the visitors. A number of Canadian soldiers were also billeted at Bramber Villa and they would doubtless

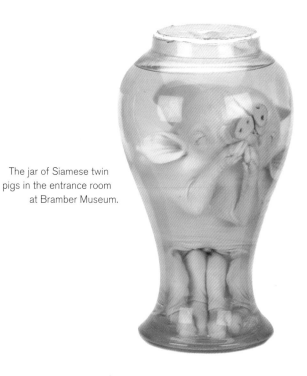

The jar of Siamese twin pigs in the entrance room at Bramber Museum.

have spread news of their remarkable circumstances to disbelieving friends and relatives across the Atlantic.

Minnie and Edgar Collins's son, Edgar Walter Collins, known as 'Eddie', had a distinguished record of war service, pioneering early radar systems. After the war he declined offers of employment with the electronics firms EMI and Phillips to follow his mother's wishes and help her look after the museum, his father having died in 1938. Eddie ran the museum as a famous and successful tourist attraction and seems to have been well suited to the job. In fact, he had probably been involved even before the war, as in 1932 he had been featured in a *Worthing Herald* article about the museum which described him as a very jolly person, 'a showman to his fingertips'. According to Eddie, the women's favourite exhibit was *The Kittens' Wedding,* while men were particularly fascinated by the freaks, but children praised *The Death & Burial of Cock Robin* 'every time'. His mother Minnie continued to help out behind the counter, as she had done for many years, until she died in January 1965.

During the winter the museum opened only sporadically, but in the summer months it was open six days a week, from 10 a.m. until lunchtime, then again from 2.15 p.m. until dusk. Admission cost threepence in 1932. The no.22 Southdown bus from Brighton stopped outside every half hour and Bramber Museum became one of the standard daily outings offered by local coach companies from the popular coastal towns of Brighton and Worthing. Adventurous tourists were attracted from further afield by frequent articles in the press. Visitors apparently included the Bloomsbury Set, and Diana Dors (Britain's answer to Marilyn Monroe) posed among the museum's offerings for some publicity photos in the 1950s. Queen Mary is also said to have enjoyed a visit.

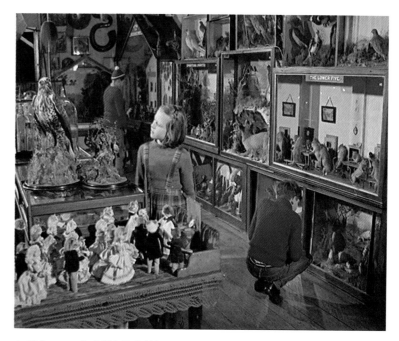

A still from a 1965 British Pathé News cinema newsreel.

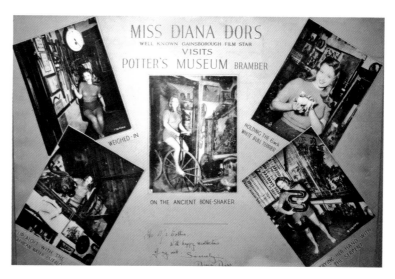

A display of photographs recording a visit to Bramber Museum by the 1950s film and TV personality Diana Dors, Britain's answer to Marilyn Monroe. It was signed by her and dedicated to Eddie Collins.

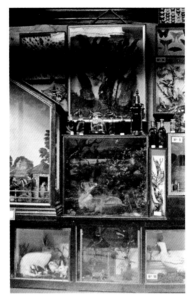

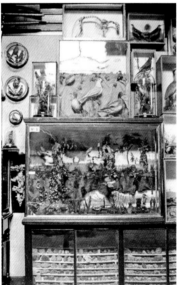
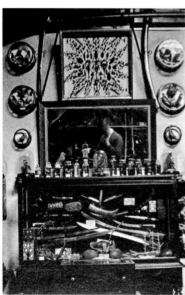

These early photographs of Bramber Museum give a good impression of the way every last space was packed with curious objects.

In 1949, Eddie Collins assembled a selection of photographs in order to strengthen the case for the local Council to accommodate Bramber's increasing numbers of visiting coaches and cars. The old museum building in the hotel yard, vacated ninety years earlier, was converted into a tea room in 1954, enhancing the attraction of a visit to Bramber and providing additional income for the museum. The prestigious *Gaumont British News* filmed the museum in 1947 for use in cinema newsreels and so did *British Pathé News* in 1965. The museum's popularity steadily increased.

Eddie Collins was assisted by his wife Nell, but when Eddie died in 1969, his widow struggled to cope. She cleared out an untidy storeroom at the back of the museum and burnt most of its contents. She then arranged for auctioneers to solicit offers for the house (Bramber Villa), garden and museum, collectively valued at £18,500. Negotiations continued from late 1970 until Bramber Museum finally closed on the last Sunday of the 1972 season.

BRIGHTON (1972–1974)

Nell Collins sold the house, with the adjacent museum building and its contents, to Anthony Irving, who wanted somewhere to accommodate his own extensive collection of smoking memorabilia, including 20,000 pipes. He needed to dispose of the Potter collection and is said to have turned down expressions of interest from the USA and also spurned Madame Tussaud's, seeking to keep the museum in Britain, preferably in Sussex. He asked a friend (a young antique dealer in Brighton called James Cartland), to help find a buyer for the extraordinary assemblage filling the museum building.

James, a relative of the famous novelist Barbara Cartland, had known the museum since his youth and decided to buy and run it himself. In a subsequent newspaper interview he mentioned that he had paid £6,500 for the collection in 1972. He later wrote that his family would have 'cheerfully committed me to an asylum [and] there have been moments when I would have gone voluntarily'. When the museum was dismantled for the journey, filling ten lorry loads, some of the exhibits of World War Two munitions were found still to be live and were removed from the collection.

Cartland moved the collection to a temporary new home on Brighton's seafront, in the Kings Road Arches. These comprised a series of cellars, below the promenade and a few metres west of the Palace Pier, formerly used by fishermen. The museum opened there for its 112th season, but this was a damp and most unsuitable place for a taxidermy collection. The museum struggled to compete with neighbouring fish and chip shops and nearby stalls selling souvenirs, candyfloss and sticks of Brighton rock. The museum's full-time attendant had to be laid off as the takings at the door were insufficient to pay his wages. James Cartland, while not expecting to make a fortune, nevertheless complained that the rent and rates, coupled with lack of visitors, made it an uneconomic proposition to be based there. The museum was open for only eighteen months before closing in November 1974.

ARUNDEL (1975–1986)

A fortuitously-timed bequest from his grandmother enabled James Cartland to move the museum again. He was able to buy the Old Post Office and Postmaster's House in Arundel, inland and some 30km from Brighton. He told the *Evening Argus* on 12 February 1975 that 'The old-world atmosphere of the town is an ideal

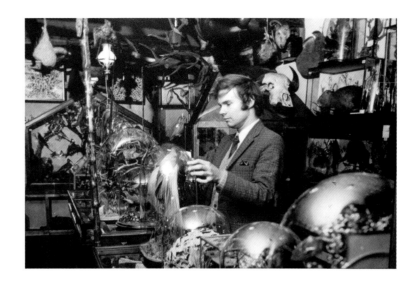

GUIDE BOOK
and
HISTORY
of
POTTER'S
EXHIBITION

251 - 258
KINGS ROAD ARCHES
BRIGHTON, SUSSEX

∞∞

OPEN MARCH TO NOVEMBER

Every day 10 a.m. to Dusk
and most weekends during
the Winter 10 a.m. to Dusk

Special Rates for Parties

*The Funniest
Animal Museum
in the world*

∞∞

Telephone
BRIGHTON
66577

James Cartland in the museum under the Brighton Promenade in 1973, surrounded by all the exhibits brought from Bramber. In front of him is a bird of paradise in a glass dome, behind his shoulder is the *Giant Coypu Rat* from the River Adur.

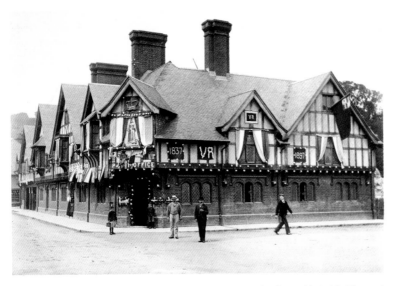

The Old Post Office as it appeared in 1897 for Queen Victoria's Diamond Jubilee. Potter's museum was later to occupy the rear portion, entered via a door at the left of this picture.

The museum's new home, the Old Post Office, was just over the bridge in Arundel. It is seen in the centre of this picture, below the spectacular castle.

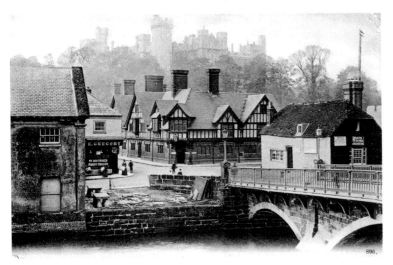

setting for the museum'. Cartland also received helpful encouragement from the Arun District Council, who were no doubt anxious to improve local visitor attractions.

This new home was a mock-Tudor house built in 1892 and located at the bottom end of the High Street. Although it was a better home for the collection than its previous one, the space was rather cramped. There were three rooms downstairs, totalling about 107 square metres (one was used for an entrance desk and small shop) and four more small rooms upstairs, totalling another 60 square metres. These were reached via a narrow wooden staircase, lined with intriguing items. There was little room for large numbers of visitors to browse the collections at the same time, and they needed to squeeze past each other rather carefully, especially on the tiny staircase.

While this added to the fun and the sense of exploration and discovery, the lack of spaciousness (and absence of CCTV in those days) made it easier for things to be stolen. A lion skin was removed, somehow sneaking it out under the nose of the custodian at the front door. A local newspaper reported in 1984 that two shoplifters had been prosecuted for the theft of a kingfisher from the museum, but many other losses went unnoticed and unpunished. About the same time, someone managed to lift off the glass covering *The Kittens' Wedding* and removed one of the animals, and a thief ripped out a bird of prey from within its glass dome, leaving just its feet attached to the base. The depressing frequency of thefts was one of the factors that ultimately caused James Cartland to give up the museum.

The museum opened in Arundel in 1975 and could be visited every day from Easter until October, and

during the winter 'some afternoons, Saturdays (and Sundays when fine)'. It featured frequently in the media, including a visit by Brian Johnson for his *Down Your Way* radio programme and a *Wish You Were Here* television programme in 1985. James Cartland told a local newspaper, 'Last year a woman spent half an hour looking around and then said she would report me to her MP for cruelty. As if I had killed the kittens myself... As it happens I am very fond of cats and have two of my own'. Despite such public disquiet, the museum attracted up to 40,000 visitors annually.

For decades, the museum continued to feature in a steady flow of newspaper and magazine articles, as far away as the USA and China. Although the press articles sometimes referred to the collection as 'curious' and 'internationally famous', commoner adjectives included 'macabre', 'gruesome' and 'weird', with allusions to 'horrified' visitors. In Canada, the *Edmonton Journal* carried an item headed 'Odd museum not ideal spot for staid folks'. Views tended to be somewhat polarised. Following a TV programme broadcast in Sweden, a woman felt moved to write to the Swedish Embassy in London to complain about the museum. Her broken English somehow adds force to her emotionally driven reaction to Potter's collection, typical of many who have been affronted over the years: 'Can this really be true that you do this to those kittens and other animals? If it is true I can not understand that anybody can be so cruel and cold hearted. Is not animals anything else to you than toys? Do people really come to the museum and looks at those ghastly things? I don't know what's the matter with you. If you don't just know that animals are living or if you are so cruel. Perhaps you are just mad. My friends think you are. To kill a lot of animal just to dress up and play with is much barbaric and can [not]

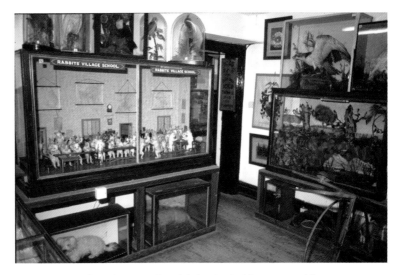

Rabbits' Village School in situ at Arundel, showing just how cramped the space was.

The Arundel guidebook, with a photograph of *The Kittens' Wedding* on the front cover.

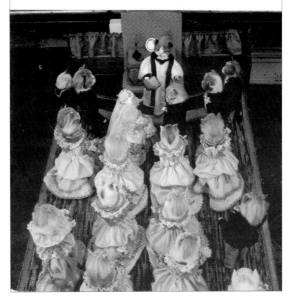

POTTER'S MUSEUM OF CURIOSITY

6 HIGH STREET, ARUNDEL, SUSSEX

The interior of Jamaica Inn with owner John Watts on the left and the author on the right.

Mr Potter's Museum of Curiosity was housed in a separate building at Jamaica Inn on Bodmin Moor.

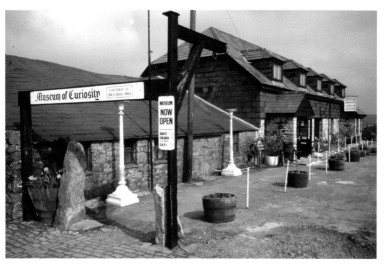

be defenced'. She ended by pleading that Mr Potter should 'get new hobby'. The Embassy forwarded the letter suggesting that she might have been sufficiently annoyed to write again, this time giving her address for a reply. Perhaps a more balanced view was that of Mr Charles Steel, Keeper of Natural History at the Brighton Museum, who told a newspaper reporter in 1973, 'The collection has no scientific value, it's true. But it should be kept as a piece of social, not natural, history. It is a period piece. It typifies the Victorian period. It is unique – thank God!'

In 1986 James Cartland decided he wished to sell the building and its contents, inviting offers in the region of £300,000. The original intention was to sell the museum as a going concern in Arundel but the National Trust declined to acquire the collection and in the end the building was sold separately from the museum specimens.

CORNWALL (1988–2003)

John and Wendy Watts bought the collection in 1986 for about £125,000, plus transport. Potter's museum joined a small collection of Daphne Du Maurier memorabilia at Jamaica Inn on Bodmin Moor, Cornwall, in a vacant building with about 200 square metres of space on the ground floor and a similar area upstairs, plus around 100 square metres in an adjoining extension. Potter's collection took up less than half this space, so there was plenty of room to add more exhibits, which the Watts set about with great enthusiasm.

The museum was reopened in its new home on 20 May 1988 by Lady Lucinda Lambton, who presented an engaging television programme about the enlarged collection. Newspapers and local television continued to feature interesting tales of the museum's development,

including the delivery of a large elephant head from London. Situated alongside the busy A30 holiday route, the museum was a popular stopover and visitor attraction, offering food and hospitality at the adjacent Jamaica Inn. It attracted some 30,000 visitors each summer, particularly when the weather was bad down at the coast.

The Watts took good care of the collection. Proper humidity control was installed, for the first time in the museum's history. This was particularly important as the collection had always been closed up for the winter in its previous locations, with many of the specimens becoming a little mouldy and losing fur.

THE END OF POTTER'S MUSEUM

A series of events around 2000–2001 required a review of the collection's future. Rose Mullins, the museum's diligent custodian, and the Watts wished to retire. Mike Grace, the taxidermist who maintained the specimens and added many of his own, died. Despite its success, the museum was not the best use of space and the inn needed more bedrooms. The announcement that the collection would be sold gained widespread national publicity in 2002. Bids were invited, but only attracted offers for individual items. One difficulty was the lack of a full list of what the museum contained and thus what a buyer might expect to purchase, so a full inventory and a promotional video were made available. After more than a year in which nobody came forward to preserve the collection intact, Bonhams was instructed to auction it in September 2003. Barely a month before the sale, a group of enthusiasts tried to raise the money to buy the whole collection, but it was too late.

The sale at Jamaica Inn was probably the most high-profile event Bonhams had ever organised. The auction

FOR OUR VISITORS' INTEREST AND INFORMATION.

May we respectfully explain that no animal, bird or insect was ever killed to become an exhibit in this Museum. Walter Potter, living all his long life in Bramber, Sussex, from 1835 - 1918, was supplied with his creatures by local farmers and breeders and, as his work became more famous, he received donated specimens from all over the world. His large Tableaux each took seven years to complete, and were first set up using cardboard cut-outs of the birds and animals, which he then gradually replaced by a little figure as and when the pelts became available. In Victorian days, "Humerous Taxidermy", as it was known, was much loved and admired, and Walter Potter's work was only distinguished by his imagination and painstaking detail. Many of the exhibits are 100 years old or more, and should be viewed - as they fully deserve to be - as a visual record of Victorian hobbies and interests, very different to today.

R. MULLINS, Curator.

Mrs Mullins' attempt to forestall tiresome complaints.

John and Wendy Watts working in the museum at Cornwall, 2003.

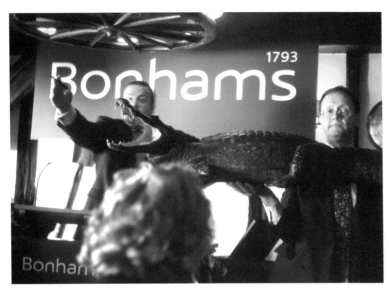

The two-day sale was held in the restaurant area of Jamaica Inn and attracted some 400 people.

The front cover of the Bonhams auction catalogue.

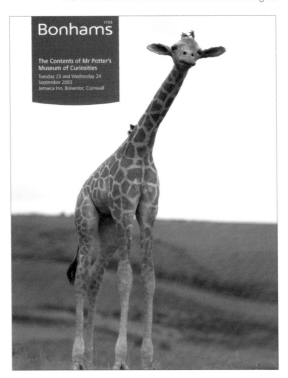

catalogue sold out in spite of its high price and the sale was spread over a two-day period on 23–24 September 2003. At the last moment, contemporary artist Damien Hirst was reported to have offered a million pounds to save the collection for the nation. Unfortunately this offer came rather late and although it was reported in the media, it seems that the owners were unaware of it, so the collection was sold piecemeal by auction.

The sale attracted over 400 people, including dealers, media folk, people from the art world, and collectors, despite the relative inaccessibility of the location on Bodmin Moor. A few minor items were purchased by Steyning Museum and returned to Sussex. The pop artist Sir Peter Blake bought *The House That Jack Built* and some smaller items. *The Kittens' Wedding* went to America (for £18,000, plus buyer's premium), as did the *Monkey Riding a Goat*. *The Kittens' Tea & Croquet Party* sold for a hammer price of £16,000, but some of the other large tableaux fetched considerably less, and sold for under £10,000 each. The most famous of the tableaux, *The Death & Burial of Cock Robin*, was sold to the Victorian Taxidermy Company for a hammer price of £20,000, the most expensive item in the sale.

THE AFTERMATH

Potter's collection was no more. After early 150 years of delighting and mystifying more than two million visitors, this unique assemblage was scattered across the country and overseas.

The Victoria and Albert Museum borrowed *The Kittens' Wedding* for a major exhibition about significant aspects of the Victorian era, yet they did not express interest in saving the core of the Potter collection and declined to accept the author's own taxidermy archive collection,

even as a gift. Many other museums in private or public ownership might also have stepped in, but did not, apparently preferring to collect the folk artefacts of foreign countries rather than preserve a unique example of English whimsy. Perhaps their reticence was due to political correctness, but the whole point of museums and art galleries is to preserve examples that typify their times, not to attempt a retrospective censorship of things that have become unfashionable.

Already some of the Potter material has been sold on. The crocodile mummy, £1,900 at the original auction, was sold by Sotheby's in 2004 for about double that. The two-headed lamb, so popular on postcards of Potter's museum, was offered on the Internet in 2004 for £3,500 (50% more than it fetched at the sale). *The Lower Five* was originally bought for £3,800 and sold on four years later for £7,500. Several significant items have gone abroad, divorced from their cultural context, and cannot now be retrieved. These are rumoured to include *The Guinea Pigs' Cricket Match & Band*, which sold at Jamaica Inn for a hammer price of £2,800 and was later bought at Olympia for more than £15,000.

Although the sale raised over half a million pounds in 2003, the core Potter collection, including all the tableaux, sold for barely £100,000. Doubtless Mr Potter would have considered these prices as amazing as visitors found the diversity of his collection. He would also surely have been disappointed by the lack of vision shown by the official custodians of British heritage. It appears that taxidermy and its part in English social history is appreciated by some, but sadly many of those with the strongest interest and commitment do not live in England. Potter's work is now scattered at home and abroad, precluding any prospect of ever re-assembling the collection again.

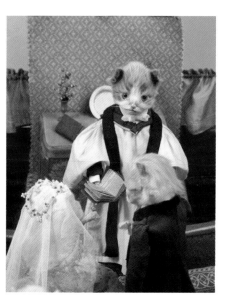

(top) The kittens are now getting married in Chicago, divorced from their social and historical context.

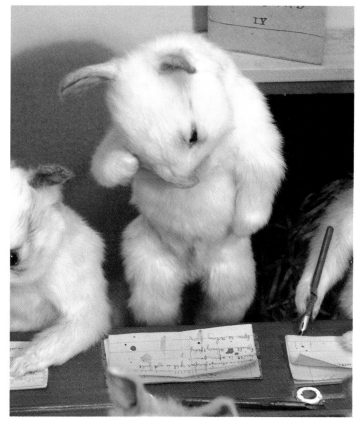

(bottom) A tearful rabbit shows frustration at his schoolwork, perhaps providing a suitable metaphor for the fate of Potter's collection.

The Original Death & Burial Of Cock Robin

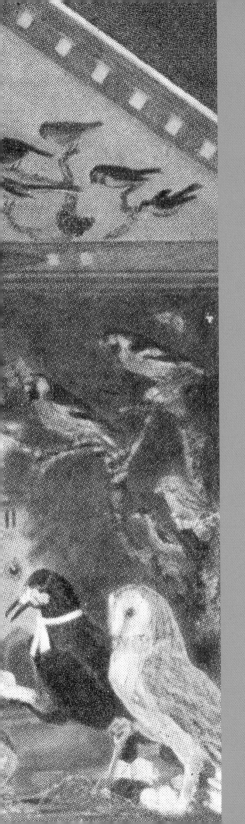

TABLEAUX

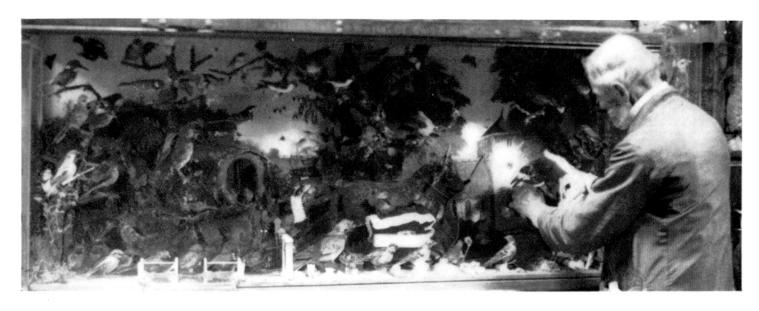

An elderly Walter Potter making some small adjustment to his Cock Robin tableau.

The anthropomorphic tableaux – cases of stuffed animals depicting a human scene – were the most famous and distinctive items in Potter's tiny museum; but for these, he and his collection would have been forgotten long ago. Today they show us what some aspects of Victorian life would have looked like and in Potter's day many people would have instantly recognised the scenes. There is no question that the tableaux, as social commentaries, were both original and intriguing at the time they were first exhibited. Only later would there develop more ambiguity in people's reactions to what they saw before them.

Most of the tableaux were carefully planned in advance and not made up in progress. Before the taxidermy commenced, Potter would often cut out cardboard figures and arrange them in the appropriate places until suitable animals became available. However, some of the tableaux were modified as Potter tinkered with the details. This is particularly apparent in *The Death & Burial of Cock Robin* case, the prime exhibit in Potter's

collection. Here, sometime after the scene was 'finished' in 1861, an additional box was added to the back of the case to allow more mourners to join the funeral party. About 1960, electric lights and indicator bulbs were also added. Torch bulbs lit up to identify key features when buttons were pressed, but these burnt out frequently and were replaced by light-emitting diodes in the 1980s. After its case had been substantially completed, the squirrels' club gained some new members, inspired by a newspaper photograph. The museum's postcards also provide evidence of change over the years, at the instigation of the various curators that followed Walter Potter himself.

Potter also created a number of smaller cases depicting other children's stories, or tales from customers in his father's bar. The stories would perhaps have been more familiar to Victorian visitors, when they would have been in wider circulation than today. Some would have struck a chord with older people, reminding them of their own childhood and schooling. Others, such as those depicting the activities of rats, would stimulate lively discussion about their veracity and about rat behavior in general. Again, rats and their activities would have been much more familiar to people then than nowadays.

One such smaller case, *The Guinea Pigs' Cricket Match & Band,* was probably Potter's third tableau and featured thirty-five animals. It measured 67 x 75 x 25 in (170 x 191 x 64 cm). The cricket match, started in 1873, is now frozen in time with the score standing at 189 for 7. Several of the players look a little corpulent for such activity, but the batsman, whose predecessor made thirty-four runs, concentrates intently as the bowler gets ready and the umpire stands patiently with hands clasped behind his back. The wicket keeper crouches expectantly and the scorer has refreshments

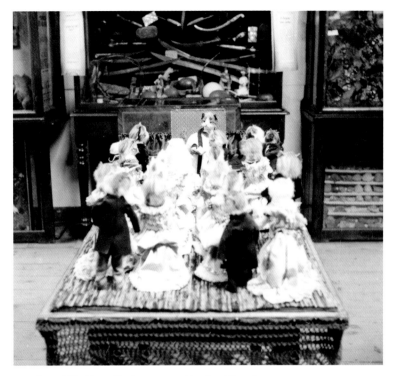

The Kittens' Wedding with glass removed in situ at Bramber.

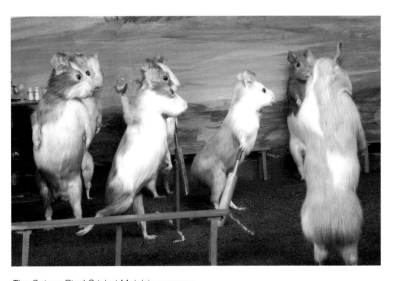

The Guinea Pigs' Cricket Match in progress.

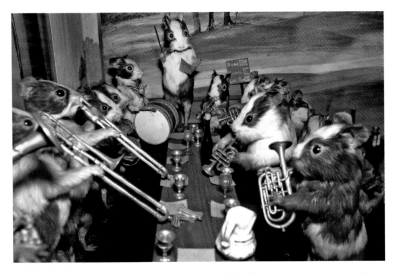

The instruments played by *The Guinea Pigs' Band*, were made especially by Potter pouring molten tin into tiny moulds. The scene is typical of the volunteer brass bands that used to play at sports matches and other outdoor social functions in the summer months.

(above and top right) The toads begin to play when a visitor puts a penny in the slot to activate an electric motor driving the animals.

to hand from the nearby tent. All is ready for the next ball, which will now never be delivered. One of the nearby bandsmen is being ticked off by the conductor for paying too much attention to the cricket.

The other bandsmen are seen playing silver trumpets and other tiny musical instruments. Potter made these by carving moulds out of chalk, following the designs shown on a musical instrument catalogue. He melted tin in a clay pipe and poured it into the moulds, but the moulds often cracked on contact with the molten metal. Each instrument took him up to two days to make, and the whole job represented six months' work, owing to the difficulty of getting the molten tin to reach all parts of the mould. Potter told a visitor 'when I was in bed and asleep I worked them out in my dreams'.

The Athletic Toads, Potter's only mechanical tableau, portrays eighteen toads enjoying a sunny afternoon in the park. This case measures 57 x 47 x 15ins (145 x 120 x 38cms). They play on the swings and a see-saw, mechanically driven when an old penny is put in the slot. A couple are playing leap-frog (although perhaps 'leap-toading' would be more appropriate), with one bending down as another prepares to jump over it, while an elderly onlooker watches intently. Perhaps this is grandpa, seated on a rock and leaning on his walking stick. He glumly surveys this scene of youthful activity, no doubt disapproving of all this jollity and at the same time regretful of his own lost youth. A young toad bowls his hoop, a popular child's pastime that now seems long forgotten, although the irregular shape of this hoop suggests that the task could not have been easy.

Toads and frogs are best skinned by turning them inside out through the mouth, which is why there is no

ugly line of stitches visible on these animals' bellies. They also have similar body proportions to humans and lack a tail, so they are particularly suitable for anthropomorphic taxidermy like this. Following Potter's lead, many taxidermists used them for this purpose, especially as they could be obtained easily and in substantial numbers. By the late nineteenth century, thanks to Potter's inspiration and the fertile imagination of ingenious taxidermists, stuffed frogs could frequently be seen seated at dinner tables, and many others would be depicted playing cards, billiards or croquet, and even fighting duels with swords. Some of these displays are occasionally attributed to Potter and may even have been his work, but this cannot be certain unless his trade label is present.

WHERE WALTER POTTER GOT HIS ANIMALS

The miniature cows and a cockerel that were needed for some of the tableaux were made by purchasing small toys and gluing on real feathers or fur. Potter's own pets were also added to his expanding museum, including his white cat, neatly attired in a red bow tie, and large numbers of assorted species of birds and mammals. Many weird and interesting specimens were also added to the collection as gifts from local people, including freaks of nature from the local farmers. These included a three-legged piglet, a four-legged chicken and several examples of kittens born with supernumerary legs and even double heads. These aberrations proved particularly popular with visitors and at least five of the freaks exhibited were featured on the postcards sold at the museum for decades. Indeed, apart from some of the major tableaux, the two-headed lamb was reproduced as a postcard more often than any other single item.

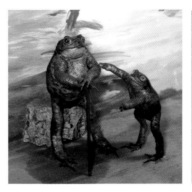
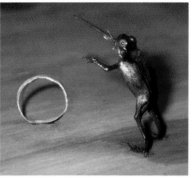

(below) These anthropomorphic squirrels may or may not be the work of Walter Potter.

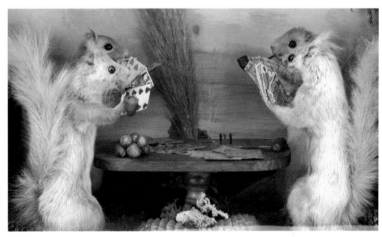

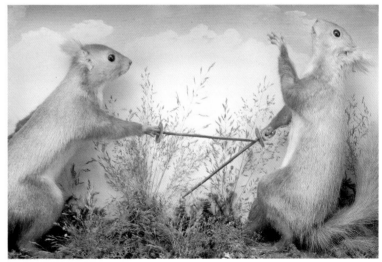

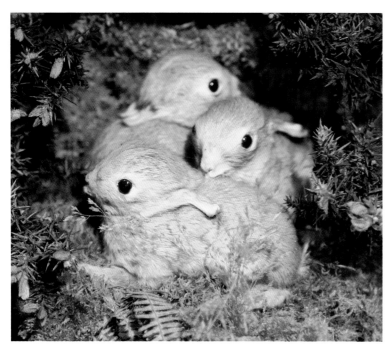

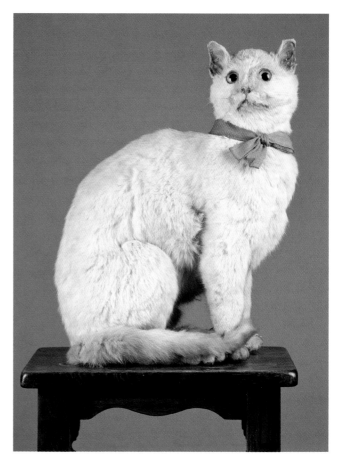

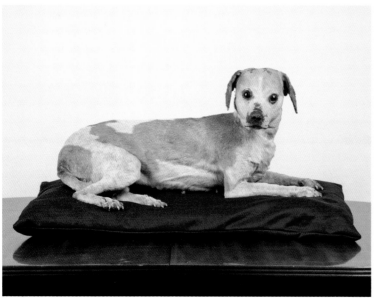

A dog called Spot belonging to one of Potter's friends (Mr Charman) caught the rats for *The Lower Five*. She also ended up being stuffed after a particularly eventful life that included being buried alive for three weeks under heaps of straw at threshing time and later being shot when she was mistaken for a rabbit. Finally, she was injured jumping out of a hayloft window in hot pursuit of a rat and had to be put down.

(above) Potter's pet cat, neatly attired in a red bow tie. The use of 'teddy bear' eyes, with circular pupils instead of narrow slits, gives an expressionless stare characteristic of many of Potter's mammals.

(top left) Visitors to Potter's museum delighted in discovering for themselves hidden details, such as these baby rabbits nestled within a case of game birds.

Many of the birds that Potter mounted were brought in by visitors who had found them dead under telephone wires or killed by local cats. Most of the kittens came from a farm near Henfield, where a number of cats roamed freely and bred without restraint. It was customary for cat owners, in those days before the spaying or neutering of cats was widely performed, to keep one of the kittens and destroy the rest; the

proprieters of Henfield farm donated their disposed stock to Mr Potter to be put to good use. Young rabbits, similarly surplus stock and infant deaths, were obtained from Mr Feast, a rabbit breeder who lived down the road in Beeding.

The squirrels, red ones in those days, were shot by local foresters and gamekeepers, particularly in nearby Wiston Park. Grey squirrels only became widespread in Sussex well after Potter's death and did not feature in his collection at all. Local farmers encouraged their dogs to catch rats in abundance and Potter was never short of them. The stuffed remains of Spot the dog, whose eventful life is detailed in the caption to the left, endured years of stroking by museum visitors until her face became quite worn.

Walter Potter confided some other details to a visitor who subsequently reported them in *The Idler* magazine in 1894–1895. Potter's confessions included the fact that some of the animals (notably rats and toads) were indeed killed by himself. This would have aroused little comment at the time, especially in respect of unwanted kittens that would anyway have been killed, usually by drowning. However, in later years, subsequent proprietors of the museum (probably beginning with Eddie Collins), responding to an increasingly concerned and squeamish public, found it expedient to gloss over this fact and even to assert that no animals had been killed specially for the museum. This claim was also consistently repeated in many magazine and newspaper articles. When the collection was on display at Cornwall's Jamaica Inn, a prominent notice attempted to deflect complaints by insisting that not only had none of the animals had been killed specially, but they were anyway all over a hundred years old.

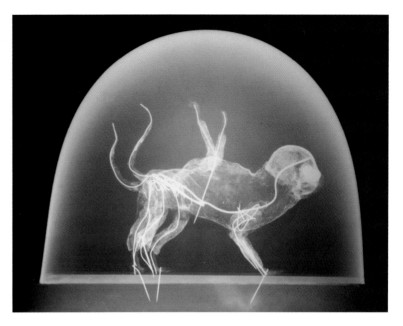

This x-ray shows an eight-legged kitten under a glass dome and the complex system of pins and wires used by Potter to support the skin.

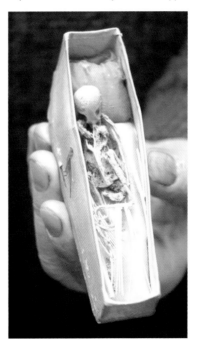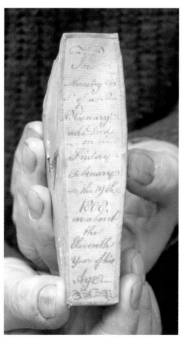

At some stage, Potter acquired the remains of this canary, who had died 19 February 1808, its skeleton sentimentally encased in a little cardboard coffin.

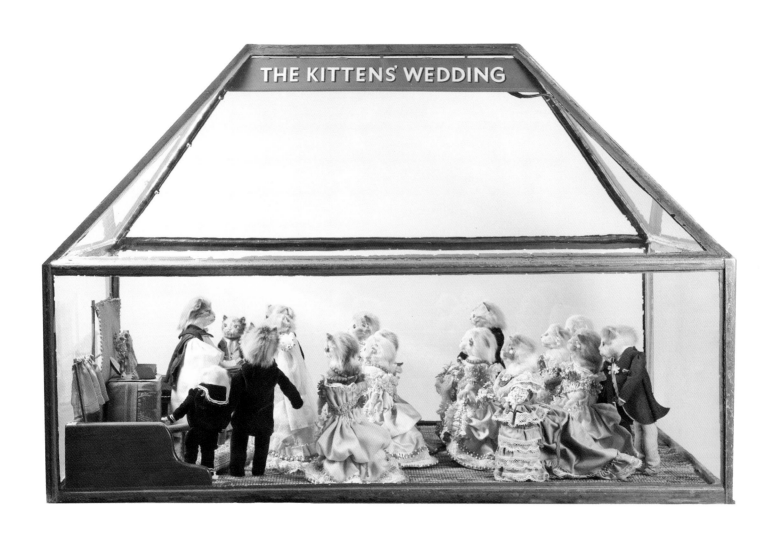

The Kittens' Wedding
Circa 1890
24 x 37 x 22 in (61 x 94 x 56 cm)

The Kittens' Wedding, completed in the 1890s, has twenty kittens wearing little morning suits or brocade dresses, and even frilly knickers (although these are not visible). The clothes were made by one of Potter's neighbours and by his daughter Minnie. This was the last tableau made by Potter, and the only one in which the animals were dressed. The case was always one of the most popular in the collection and was occasionally lent out to exhibitions at other museums (including the Victoria and Albert Museum and Liverpool Museum) as it was also the smallest of the major tableaux and therefore the most easily moved.

On this solemn occasion, the bride wears a long veil and carries a posy of orange blossom. She and the chief bridesmaid may be sisters, as they are similar in colour, as is their younger brother, wearing a little sailor's uniform (a popular type of dress for young boys, irrespective of their not being in the navy). A feline vicar in white surplice watches patiently as the bridegroom, with head tilted intently to one side, places a golden ring on his bride's finger. The vicar has his order of service book open at the page showing 'Will thou take this man…', but a male kitten standing grumpily to one side had his opened at a different page, as though lost in thought about other matters, perhaps his own relationship with the bride or disapproval of the groom. Sadly, his little book has been lost.

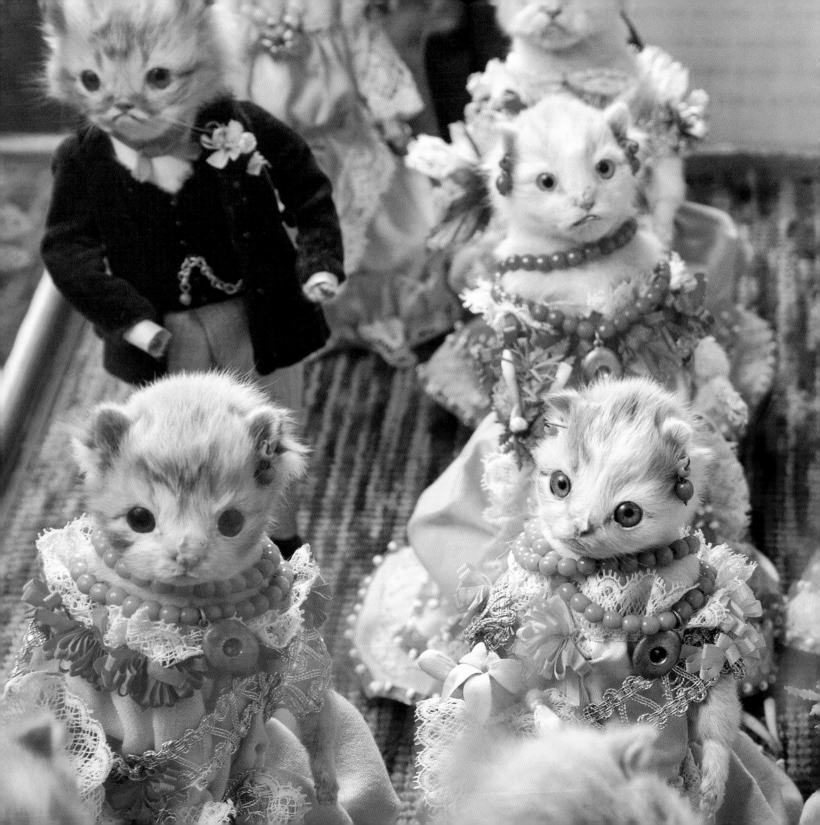

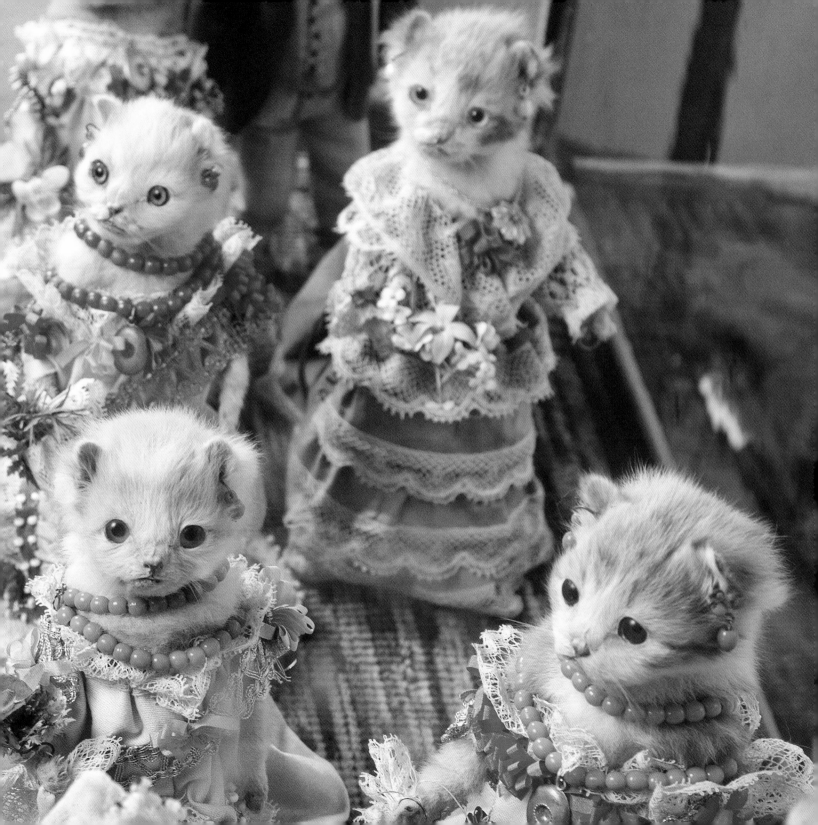

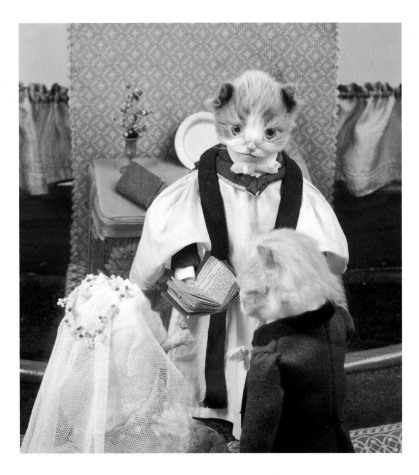

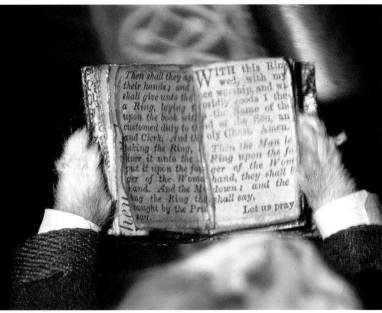

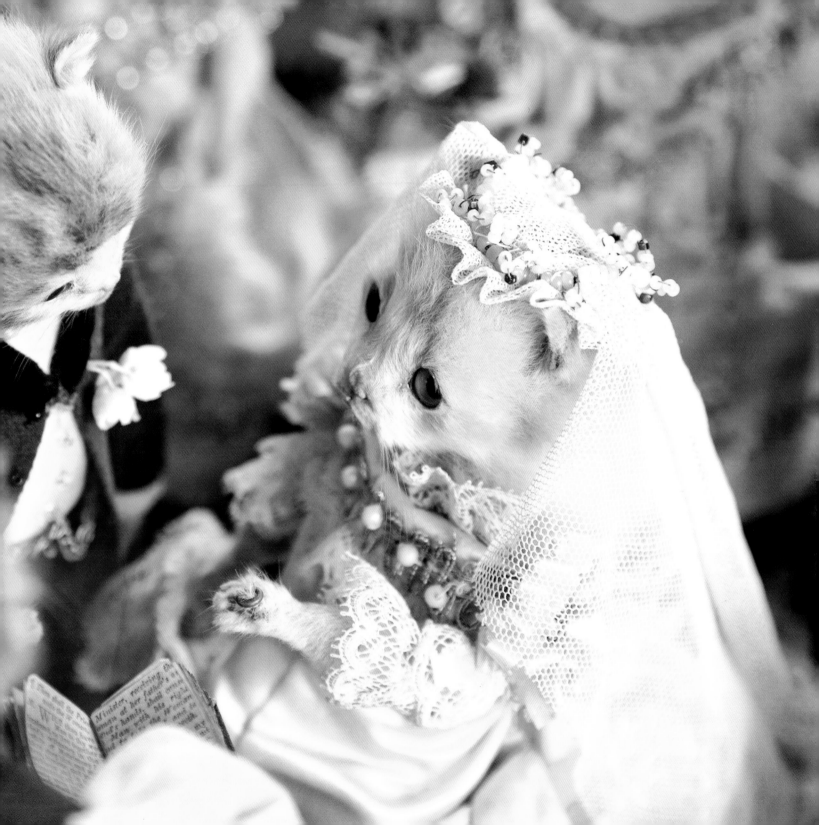

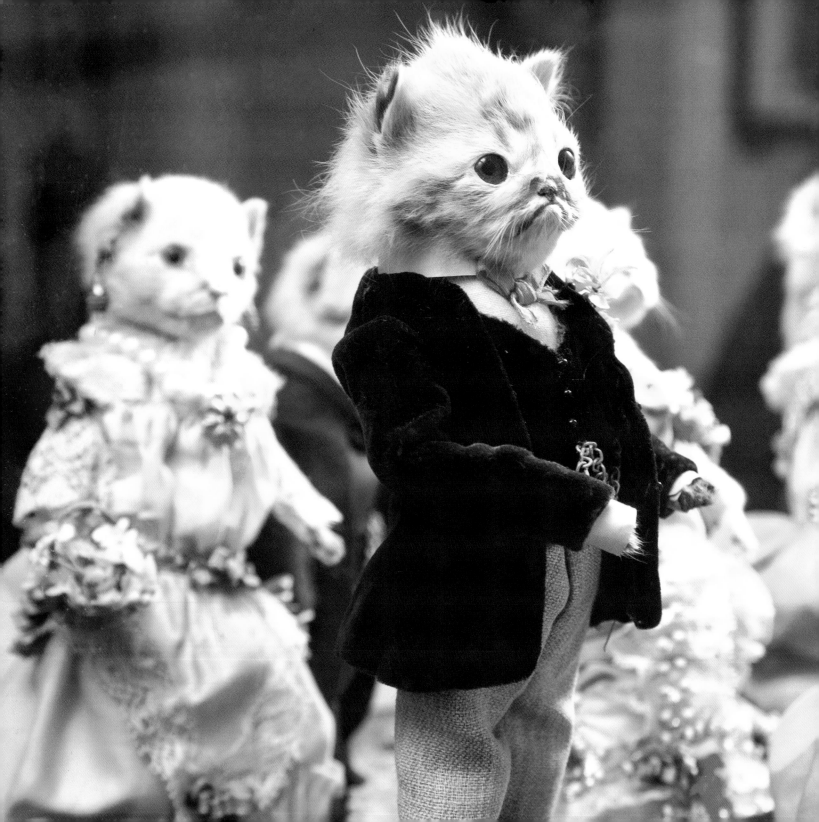

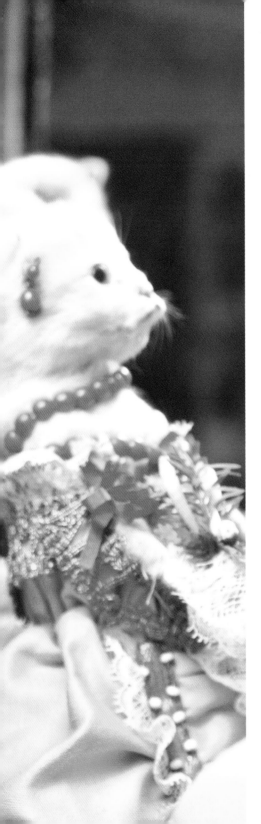

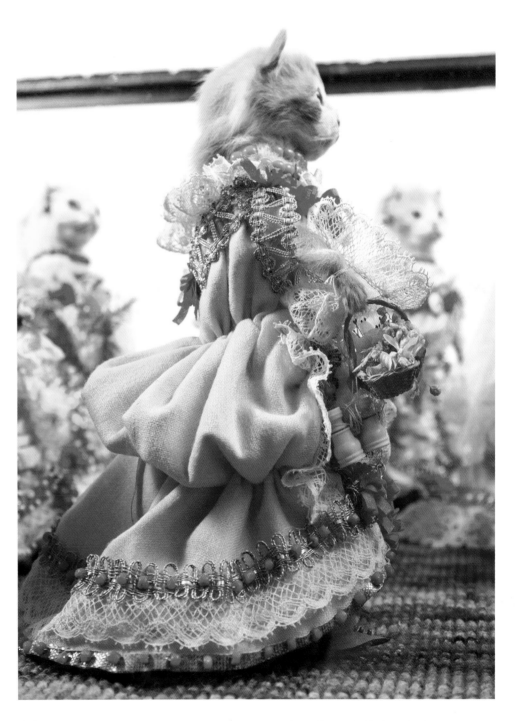

(left) This male cat looks disgruntled by the matrimonial proceedings. He once held a hymn book open at the wrong page and glued to the stumps of his paws, but it is now lost.

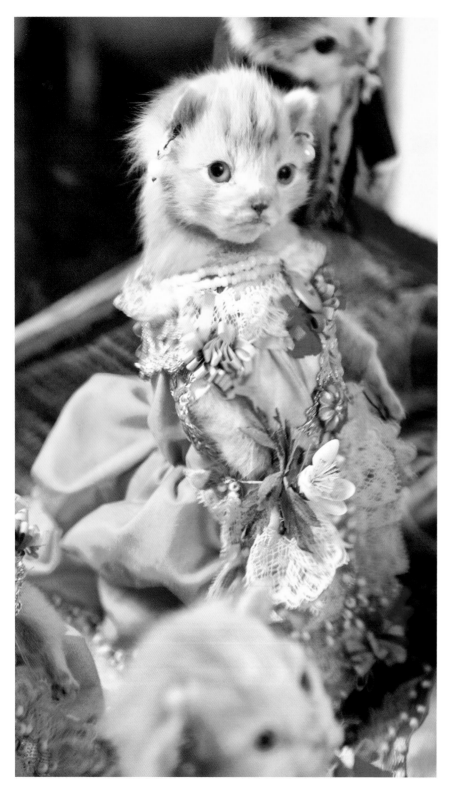
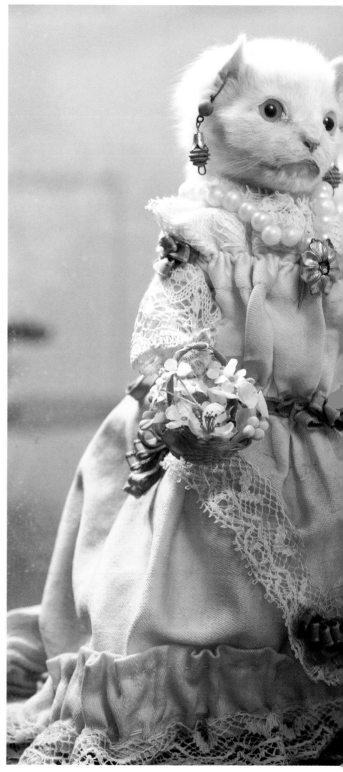

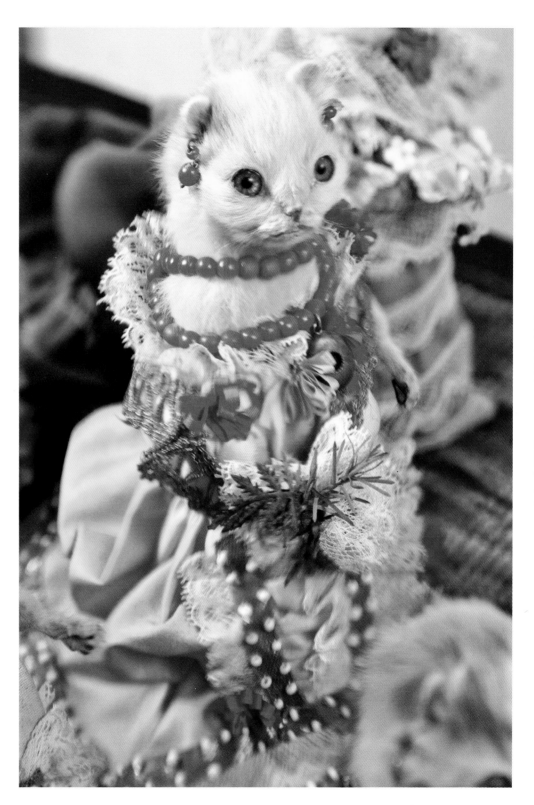

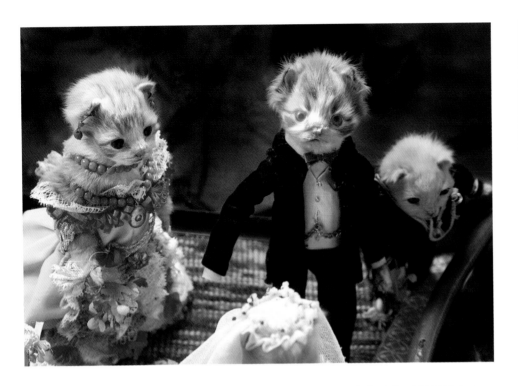
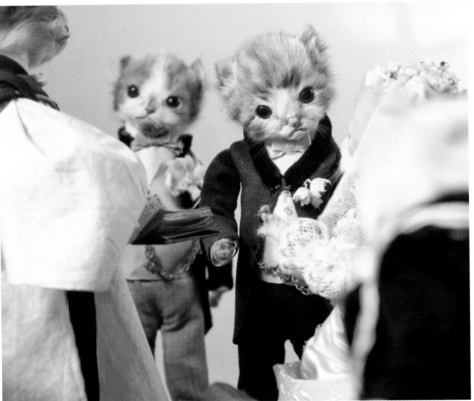
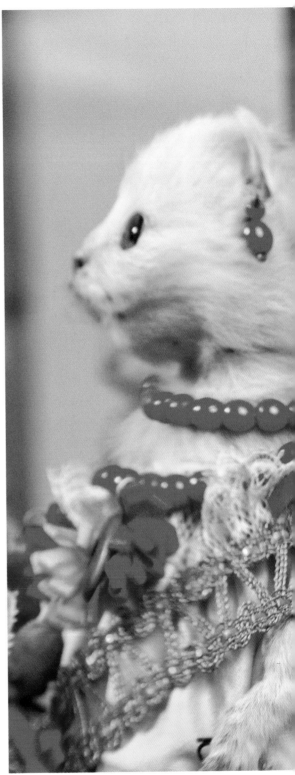

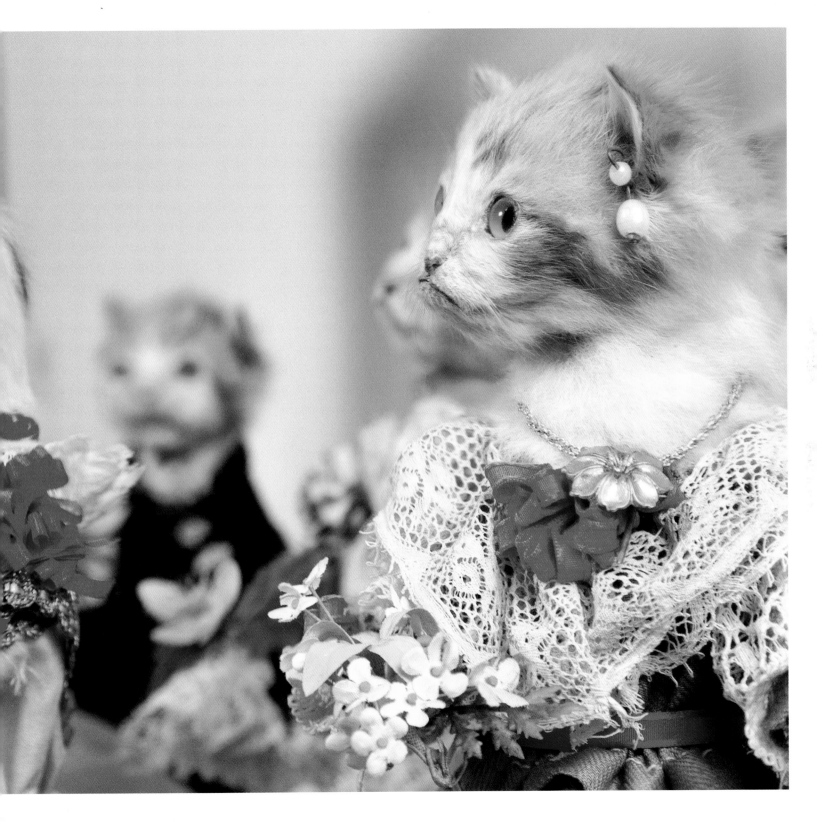

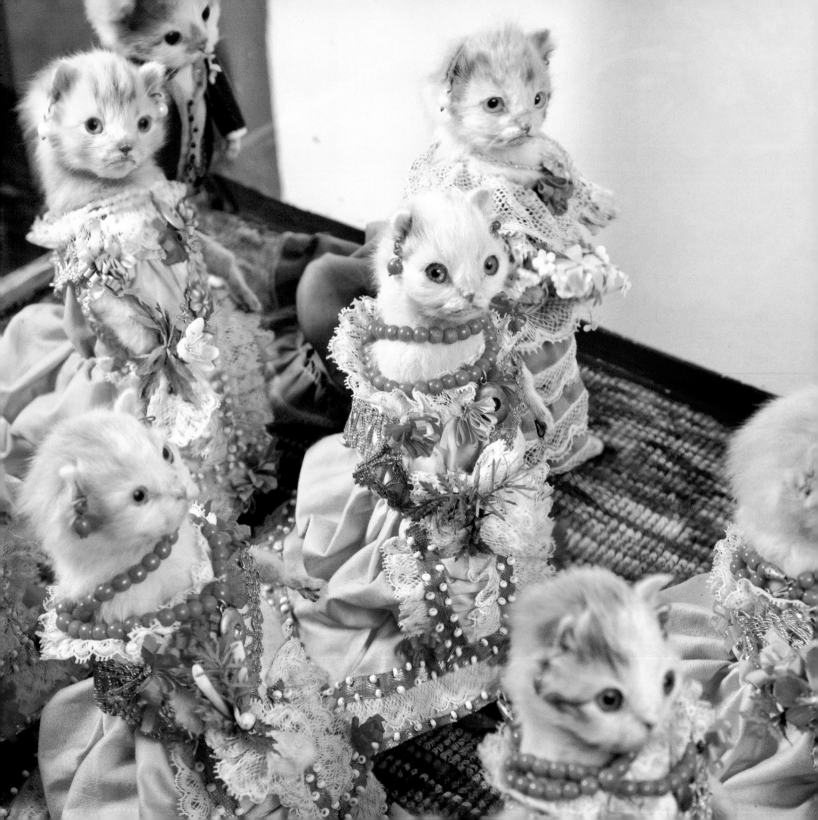

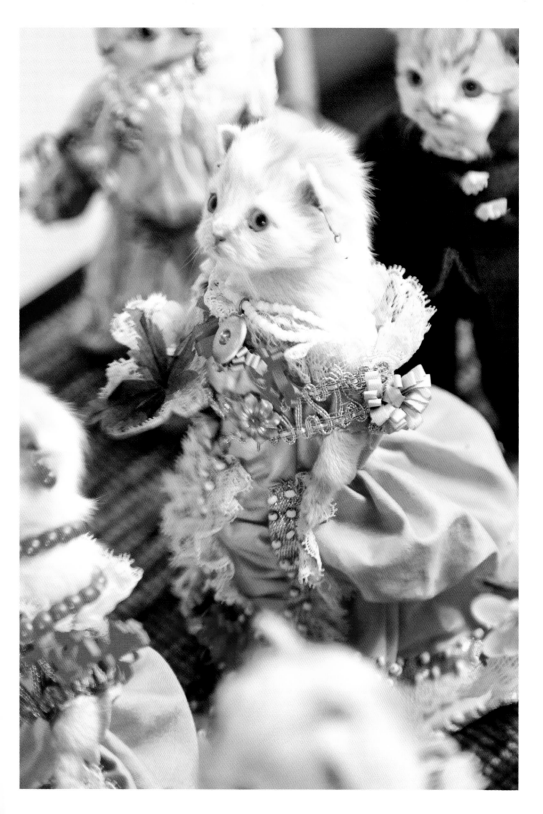
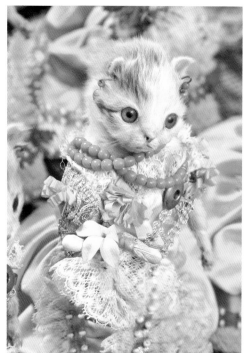
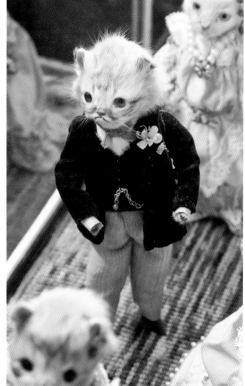

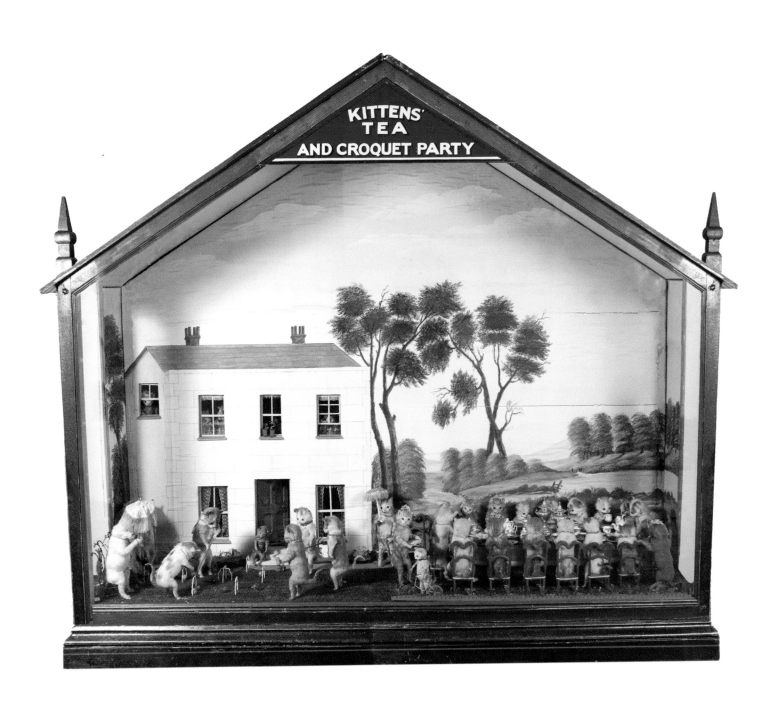

The Kittens' Tea & Croquet Party

Late Nineteenth Century

62 x 73 x 24 in (158 x 186 x 61 cm)

The Kittens' Tea & Croquet Party displays feline deportment and etiquette at its most elegant. It also includes obvious gossip among the thirty-seven kittens at this important social occasion, although one of them stares fixedly ahead, frowning at the course of the discussion and taking no part in it.

There is typical attention to detail, with tea and tiny tea-leaves in some of the cups, as well as fruit, and a cottage loaf on the table. There are cakes and scones on a plate, and also a ham, no doubt from a freshly-cured mouse. There are appropriate expressions on the kittens' faces, two of whom appear to be inspecting a timetable, perhaps anxious about the journey home, while another brushes her hair inside the house. A kitten offers a plate of tarts to a neighbour with suitable decorum, while another, wearing blue earrings, pours from an elegant porcelain teapot. She is wearing a matching crucifix and is clearly the doyenne of this dignified gathering of local ladies.

A courtly game of croquet is in progress away from the table, watched intently by kittens carrying tiny parasols to ward off the perceived threat from the sun's rays, a constant worry to Victorian ladies of leisure. In the background, an extensive park with an artificial lake suggests a rather more grand establishment than the tiny house shown.

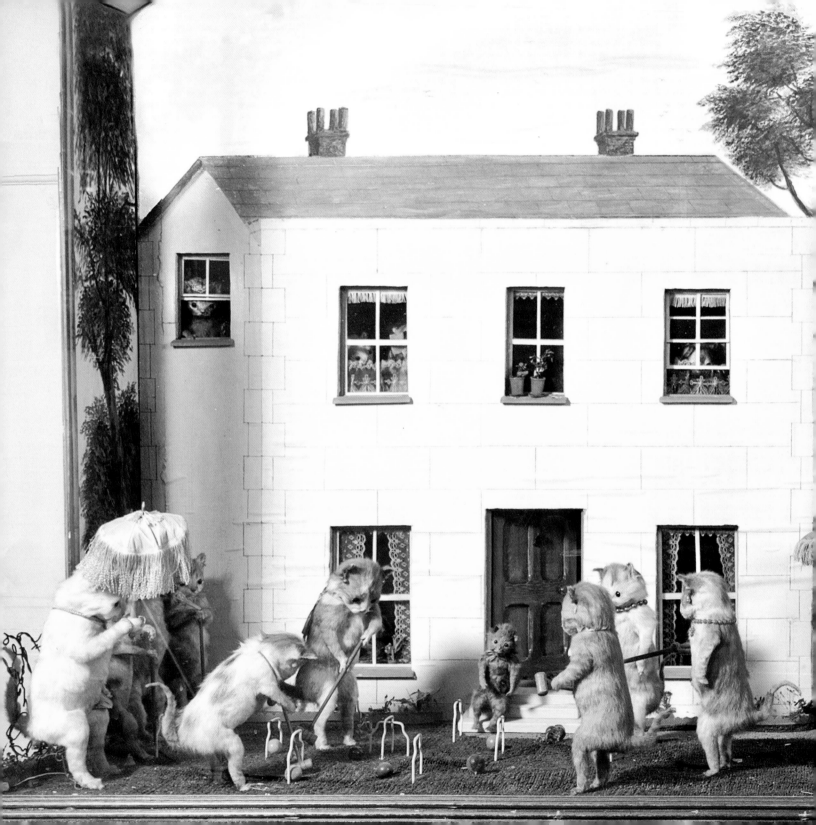

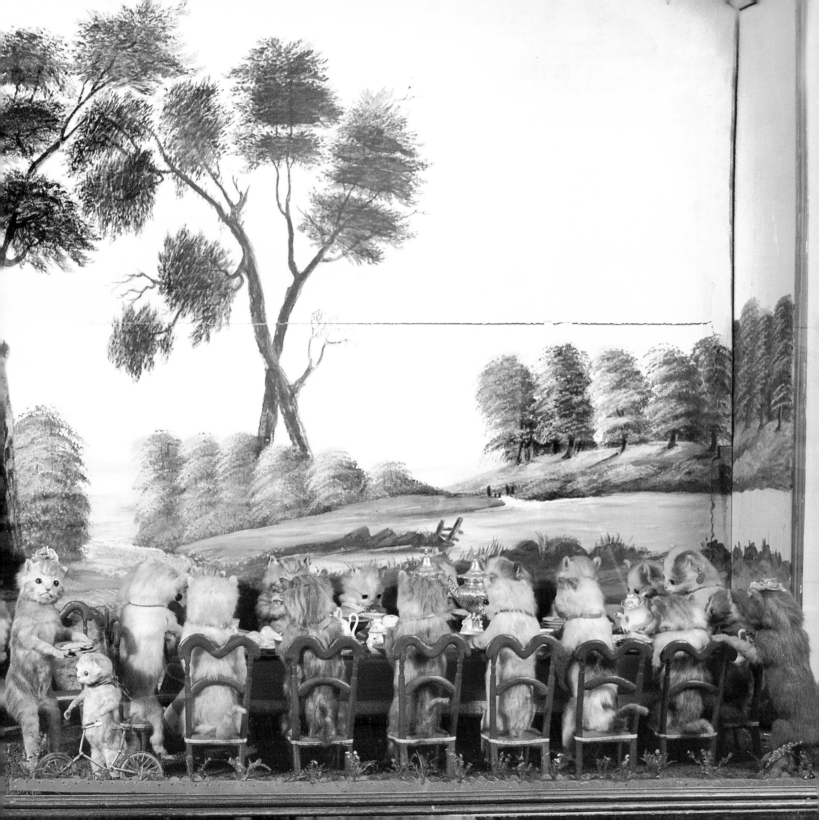

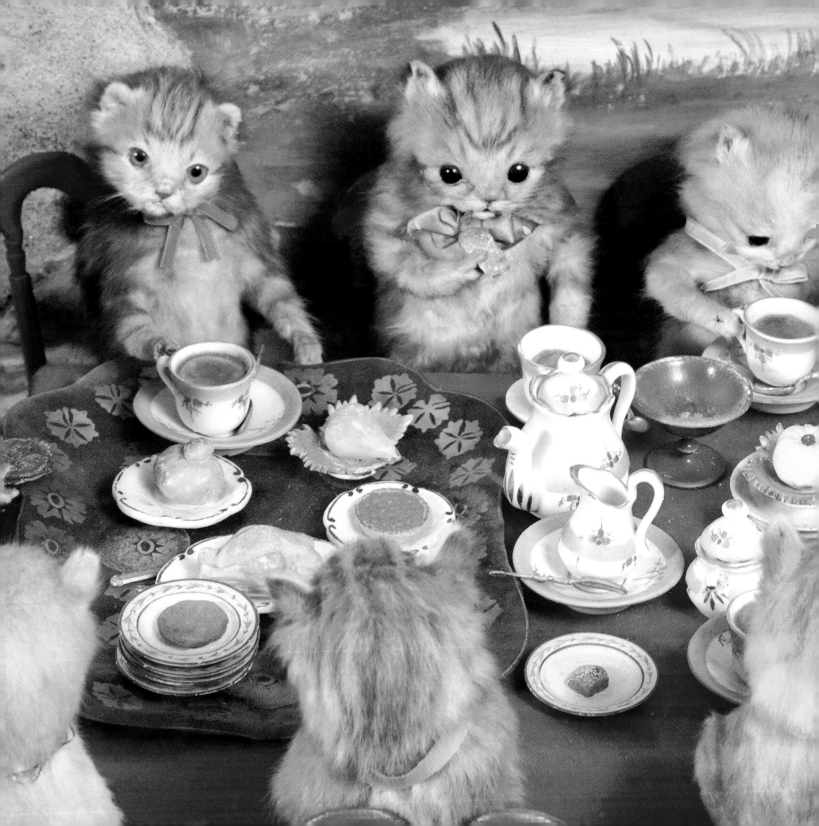

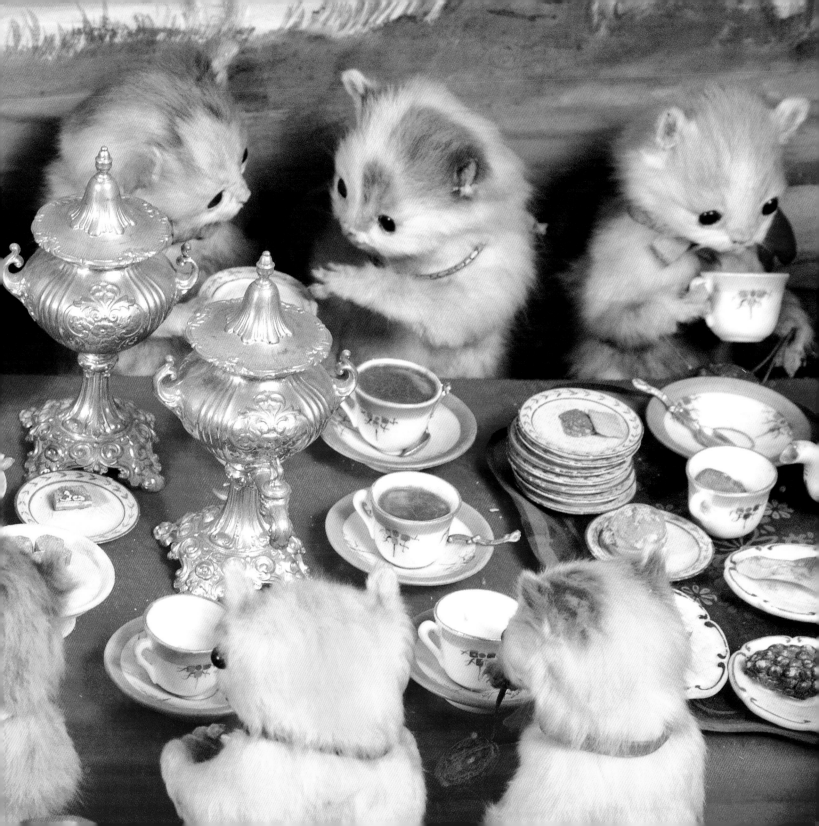

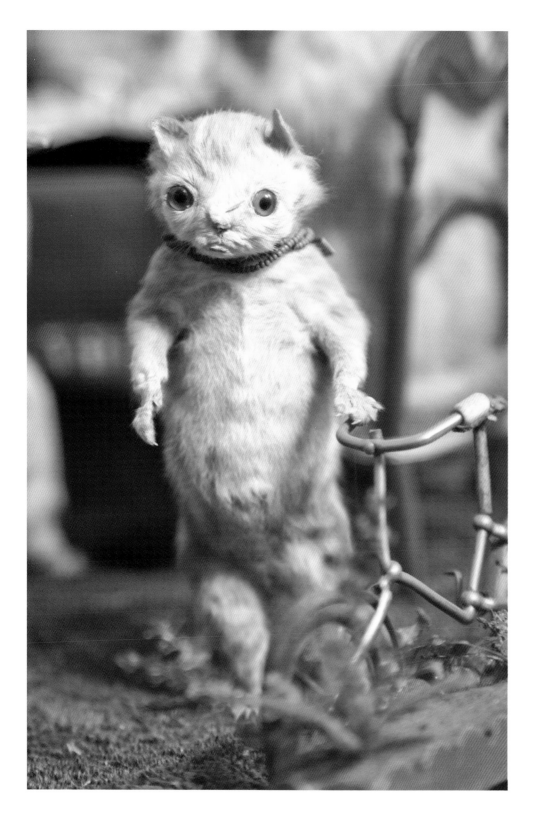
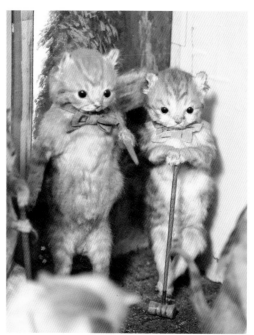
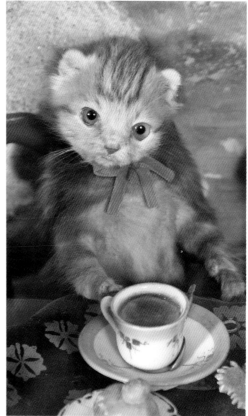

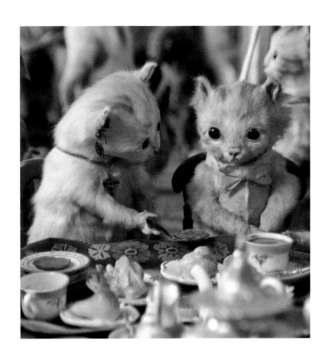
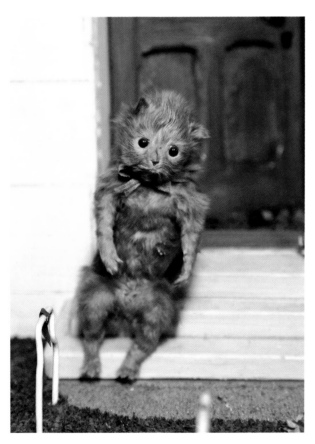
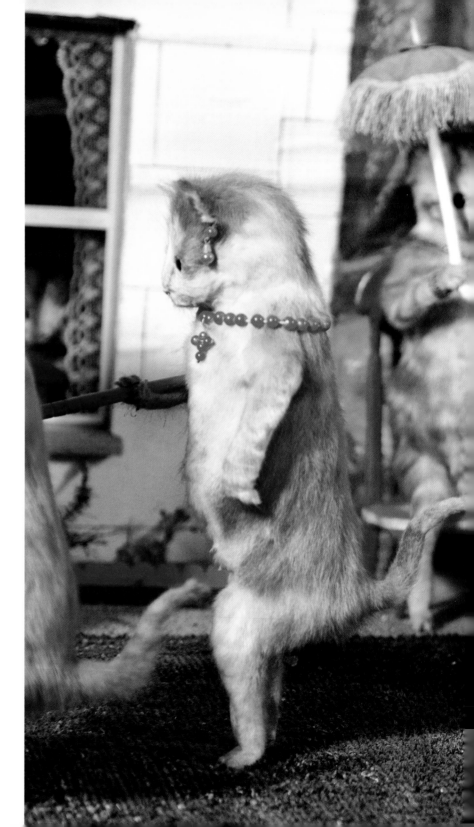

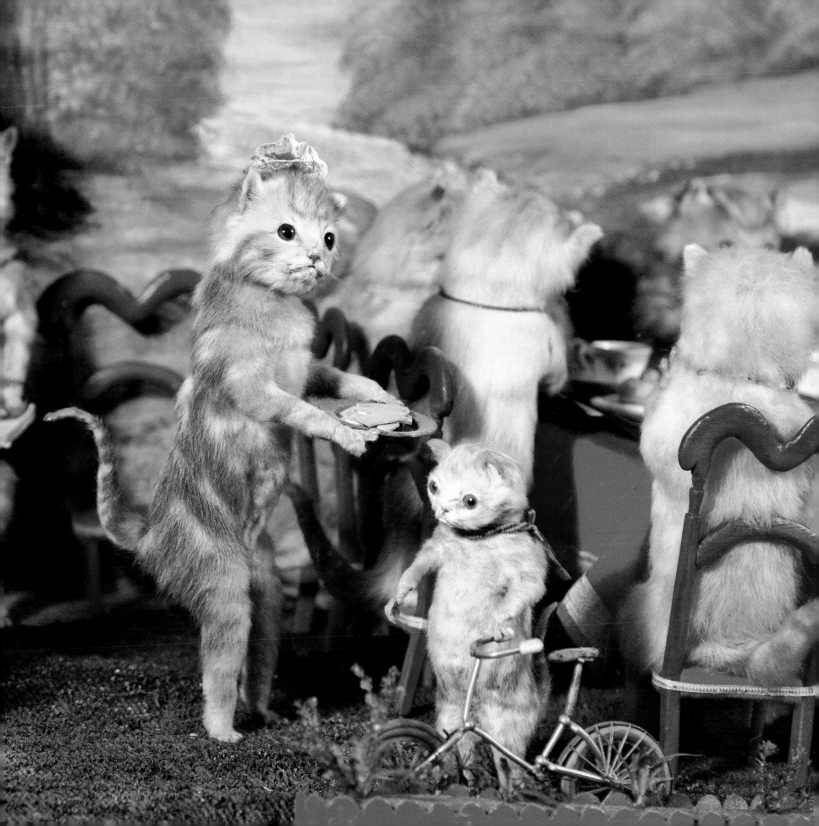

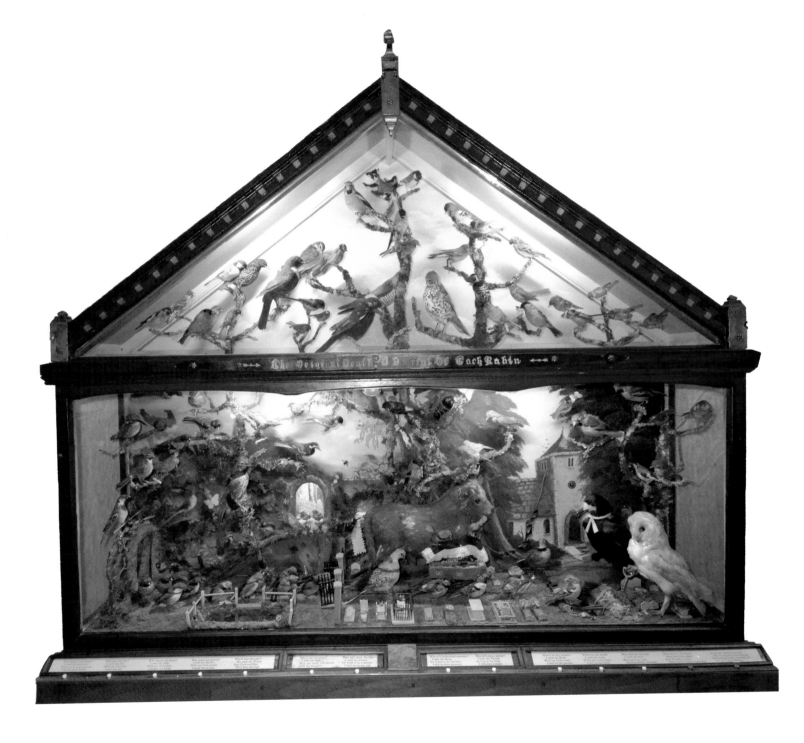

The Death & Burial of Cock Robin

1861

62 x 74 x 20 in (158 x 188 x 51 cm)

The Death & Burial of Cock Robin case is nearly two metres wide and took Potter almost seven years to build in his spare time. It features nearly one hundred British birds, some shown crying with glass tears in their eyes. Four species are included which are now rare or extinct in Sussex (red backed shrike, cirl bunting, wryneck and hawfinch), and also several canaries and at least one other aviary species. All but one of the familiar poem's fourteen verses are depicted, the missing one being a reference to the kite ('Who'll carry the coffin? I, said the kite, if it's not through the night, I'll carry the coffin'). This species would have been difficult to obtain in nineteenth-century Sussex and awkwardly large among all the smaller birds.

Otherwise, all the characters are present: the infamous sparrow is there with his bow and arrow, the rook with his book and the fish with his dish, just as in his sister's book of nursery rhymes that had inspired Potter to build this churchyard scene. The church itself is painted in oils on the back board and shows the stone construction typical among many such buildings in the Weald of Kent and Sussex. The chief mourner (a turtle dove) is followed poignantly by an adult robin (Mrs Cock Robin perhaps?) and three young ones. The solemn cortège extends down the church path, through the gate and up to the church. It stretches back under an arch, where a small mirror is installed to create the illusion of further mourners in the distance.

The original nursery rhyme speaks of carrying 'the link', a sceptre-like item of funereal significance used in Victorian times, and it is shown being borne aloft by the appropriate bird, a linnet. The bull tolling the church bell was made by gluing calfskin over a small model that Potter had purchased. The 'owl with his trowel' is actually equipped with a spade, and appears to have disinterred some of Cock Robin's ancestors in the course of digging the grave. However, these bones are actually from a sparrow. The nearby tombstones all bear initials suggesting that 'Robin' was the surname of their occupants.

Such keenly observed details are what makes the case such an intriguing exhibit. It is likely that Potter dreamt up many of these finer points and added them to the case as he went along. There are many butterflies, lichens and even a small grass snake hidden away among the vegetation, all adding to the complexity and curiosity of this exhibit. Later Potter recounted that 'all the young ladies from the school here came to see it, and one of them took her hat off and collected a few shillings'. Thus began Potter's collection as a paying proposition, although he professed that he had never intended to build up a public museum in the way that he did.

Other taxidermists copied the Cock Robin theme but none made such a large and complex scene as Potter. There was a brief dispute with Brighton taxidermist William Swaysland as to who had thought of the idea first. On 8 July 1869, an article in the *Brighton Gazette* described Potter's creations disparagingly as '…the work of a labouring man' and asserted that better was to be seen at the premises of Mr Swaysland. A full description of his own *Death of Cock Robin* case followed, including reference to a kite (part of the original poem, but not present in Potter's tableau), adding 'The birds are so well stuffed and posed and the smallest details so carefully studied, as not to leave the slightest objection to be found. Mr Swaysland has spent a considerable period in [its] preparation and, as one of our best naturalists he has surpassed his previous commendable productions'. The article ended by reminding readers that 'The Death and Burial' 'may be witnessed at Mr Swaysland's premises at a charge of sixpence'. One suspects that the disingenuous hand of Mr Swaysland himself had been employed in writing to the newspaper.

Potter's response was restrained and dignified, asserting that he was a naturalist, not a labourer. He also pointed out that 'Mr S' had both plenty of time and opportunity to copy his own tableau, and his several visits to Bramber museum over the past eight years would doubtless have helped him to do so. Potter also installed a long metal strip on his own case proclaiming it to be *The Original Death & Burial of Cock Robin*.

(right) In preparing the grave, some sparrow bones have been dug up, suggesting that this burial ground is already a little overcrowded. A chaffinch holds one of the straps that will later lower the coffin into its final resting place. The tombstones bear initials, the second of which corresponds to 'Robin', implying that this is the family burial area. The date, 1862, is later than the main completion of this case, suggesting that Potter continued to add details to the scene.

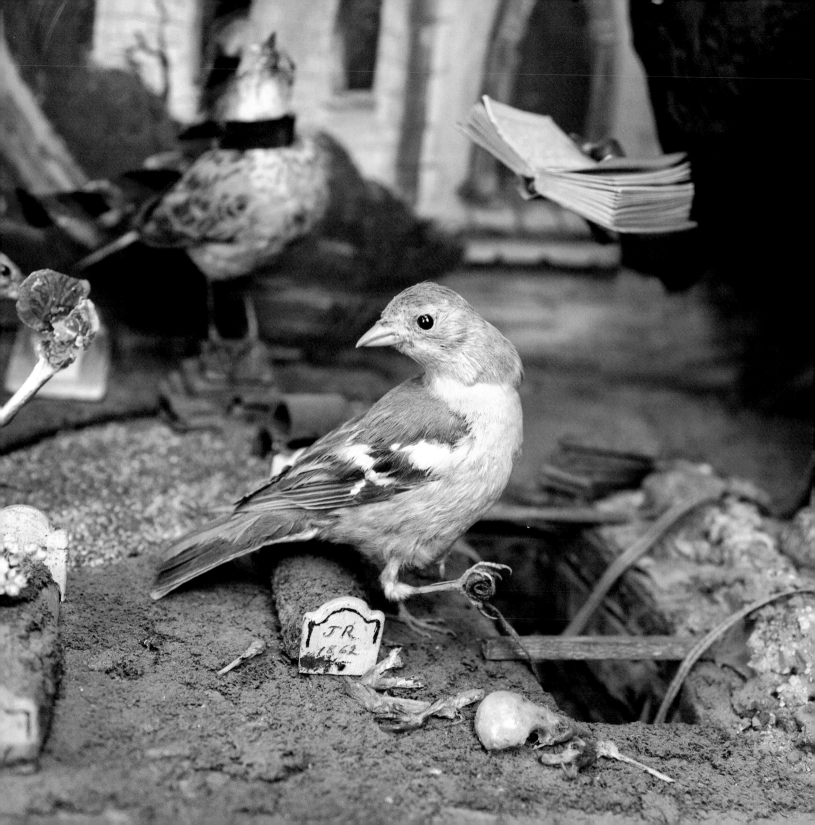

Fly,

Beetle;

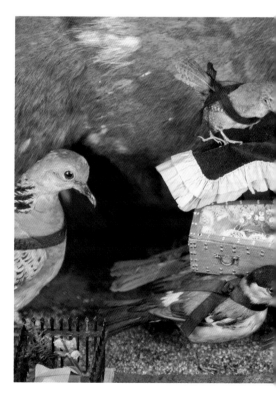

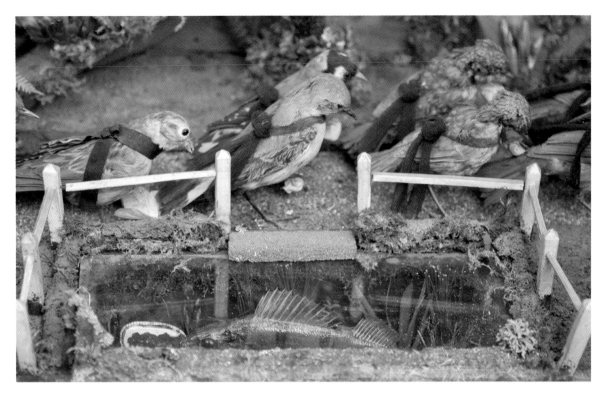

The rhyme as it appears on the case is set out here:

Who killed Cock Robin?
I, said the Sparrow;
With my bow and arrow,
I killed Cock Robin.

Who saw him die?
I, said the Fly,
With my little eye,
I saw him die.

Who caught his blood?
I, said the Fish,
With my little dish,
I caught his blood.

Who made his shroud?
I, said the Beetle;
With my little needle,
I made his shroud.

Who'll bear the pall?
We, says the Wrens,
Both Cock and Hen,
We'll bear the Pall.

Who'll dig this grave?
I, said the Owl;
With my spade and shovel,
I'll dig his grave.

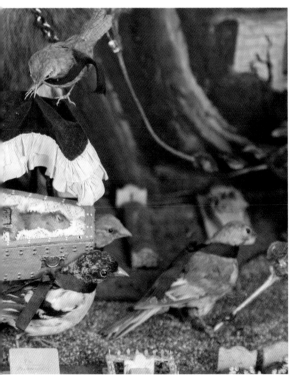

Who will carry the link?
I, said the Linnet,
I'll fetch it in a minute,
I will carry the link.

Who will be chief mourner?
I said the Dove,
For I mourn for my love,
I will be chief mourner.

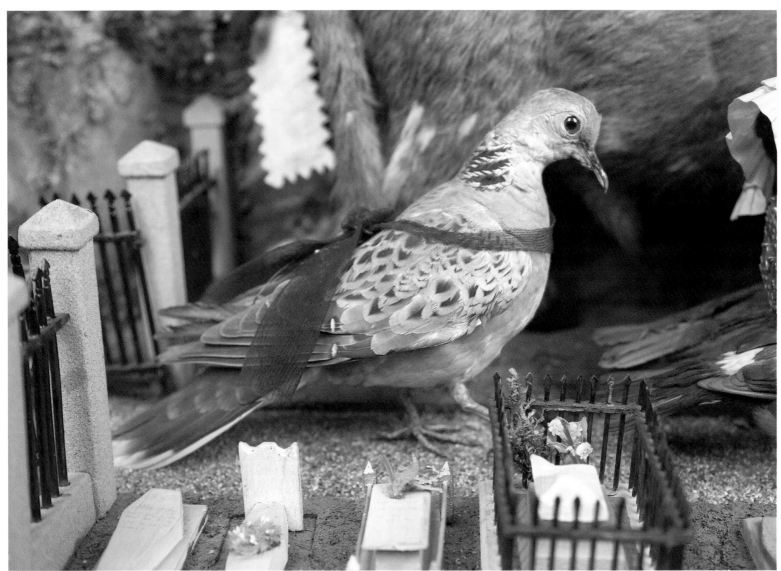

Who will sing a psalm?
I said the Thrush,
As I sit in the bush,
I will sing a psalm.

Who'll be the parson?
I, said the Rook,
With my little book,
I will be the parson.

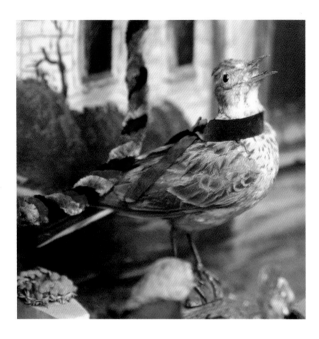

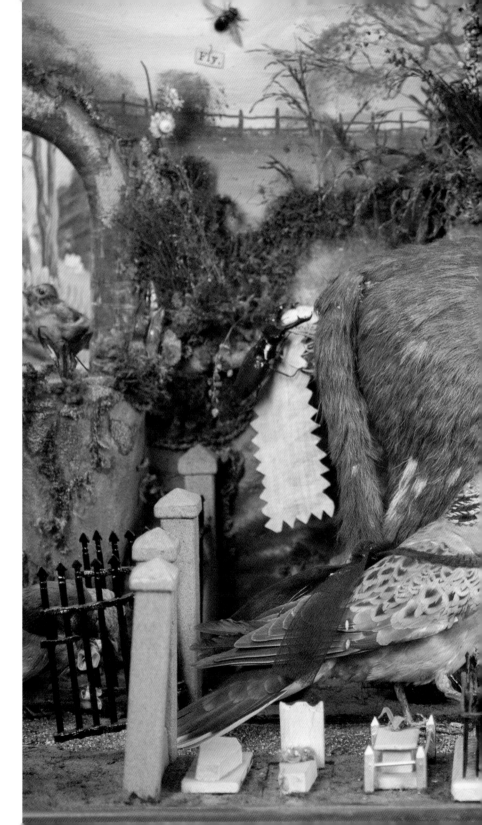

Who'll be the clerk?
I, said the Lark,
If it's not in the dark,
I will be the clerk.

Who will toll the bell?
I, said the Bull,
Because I can pull.
So Cock Robin, farewell.

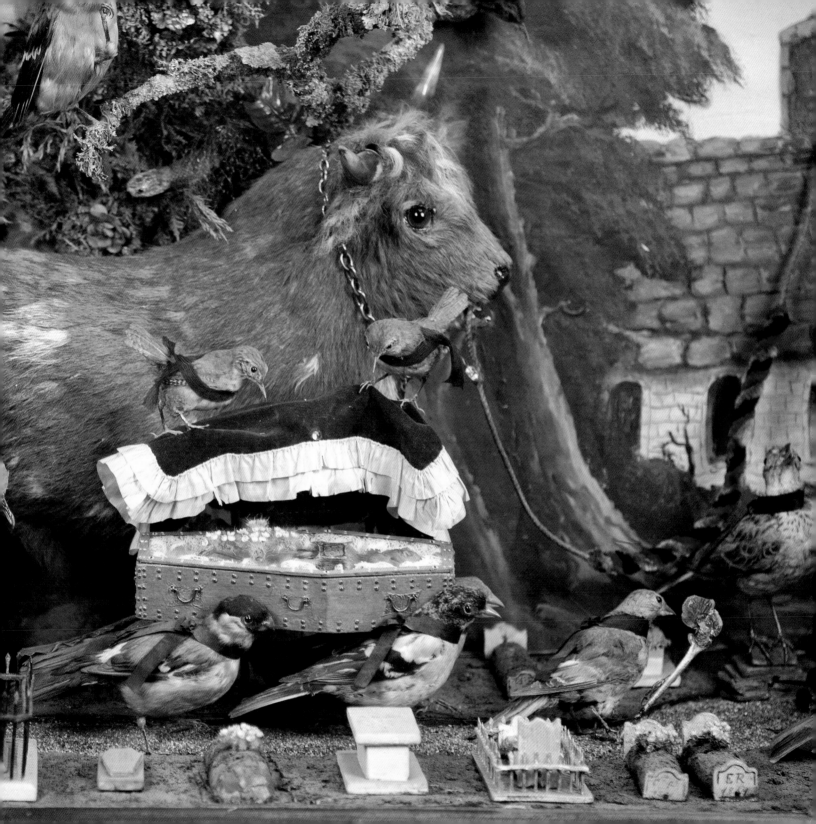

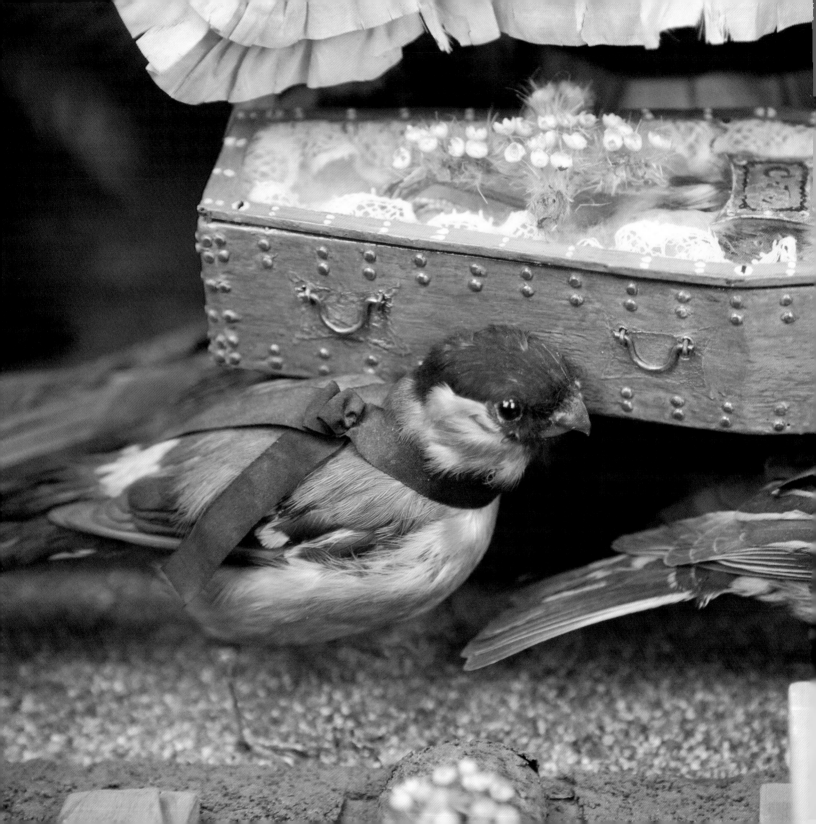

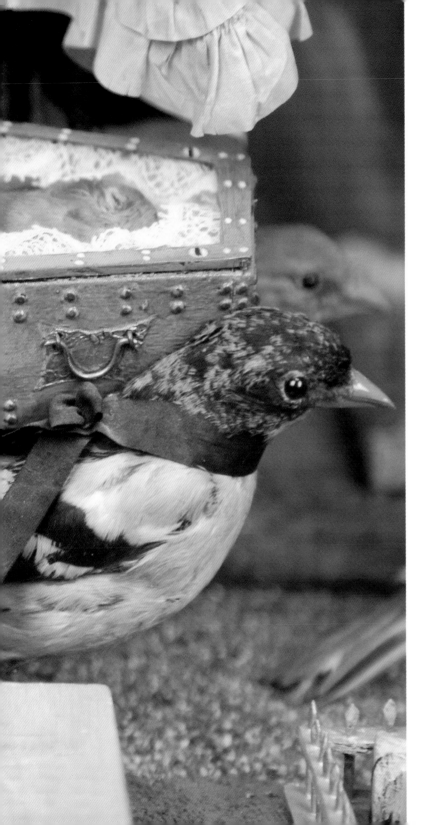

Then four of the Party
Soon bore him away,
And so sadly ended
Cock Robin's unfortunate day.

(left) A brambling and bullfinch (and sparrow and redstart out of sight) carry the coffin on their shoulders. Cock Robin's fatal wound is also visible.

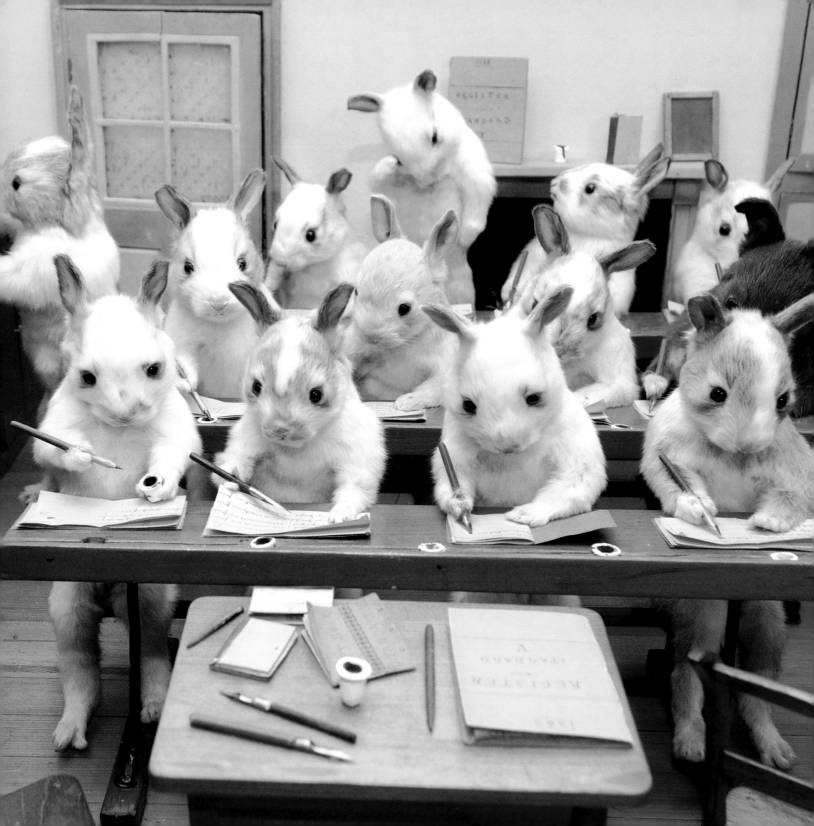

Rabbits' Village School

Circa 1888

42 x 73 x 20 in (107 x 186 x 51 cm)

Potter wanted fifty baby rabbits for the *Rabbits' Village School*, but despite asking around in the local villages, he could only get the forty-eight that are here engaged in scholastic activities. The pupils are all about a month old, the two teachers somewhat more. Potter made all the slates (from paper), pencils and furniture himself, but asked his wife Ann to create the tiny clothes seen in the needlework group. The inkwells were carved from small sticks of chalk. Four classes are shown in progress, sometime in 1888, as shown in the open class register. One of the pupils in the writing class has blotted his copybook and is standing on the bench in tears, probably having been caned for his carelessness. One of his neighbours watches derisively – or is it sympathetically? The classroom door is slightly ajar as a small rabbit creeps unobtrusively back into the room, perhaps having just returned from a trip to the lavatory.

The girls in the sewing class include one who has darned the heel of a sock and is proudly showing it to her neighbour, while others inspect the stitching in a red petticoat. In the centre of the case, a group stands reading a book about the opening of Westminster Bridge in 1862. One member of this group turns to help his friend who is struggling with his arithmetic. Another rabbit at the back of the class has his hand raised in an effort to attract the teacher's attention. There is some consultation going on in the arithmetic class, where the rabbits wrestle with the challenge of adding up and long division. They are busily writing in chalk on their tiny wooden-framed slates. One has got his sums wrong and is in disgrace; another tentatively shows his work to the teacher. A neighbour is still sharpening his pencil, perhaps as an excuse for not committing himself by writing down his computations. The school monitor is putting away the class register in a tall desk. A cane hangs menacingly on the wall below the clock, a silent warning to any that might misbehave.

These tiny rabbits personify youthful innocence, deeply engaged in their school work. The scene reflects typical school life for children in late Victorian times, similar to the schooldays that a young Walter Potter himself would have experienced, perhaps in the very same village school that he visited in 1888 to gain inspiration for the construction of this case.

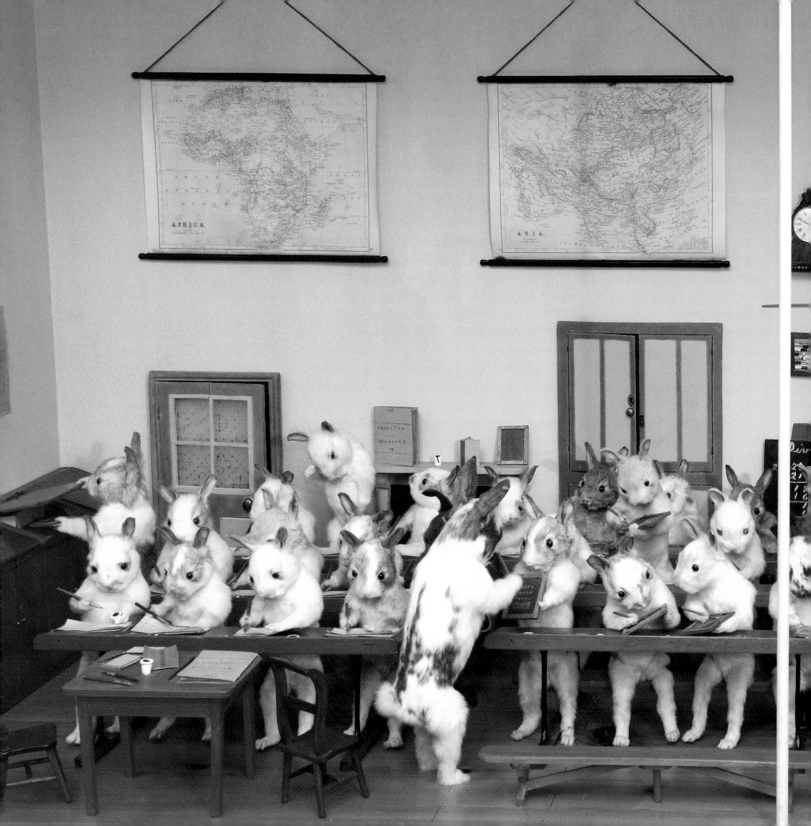

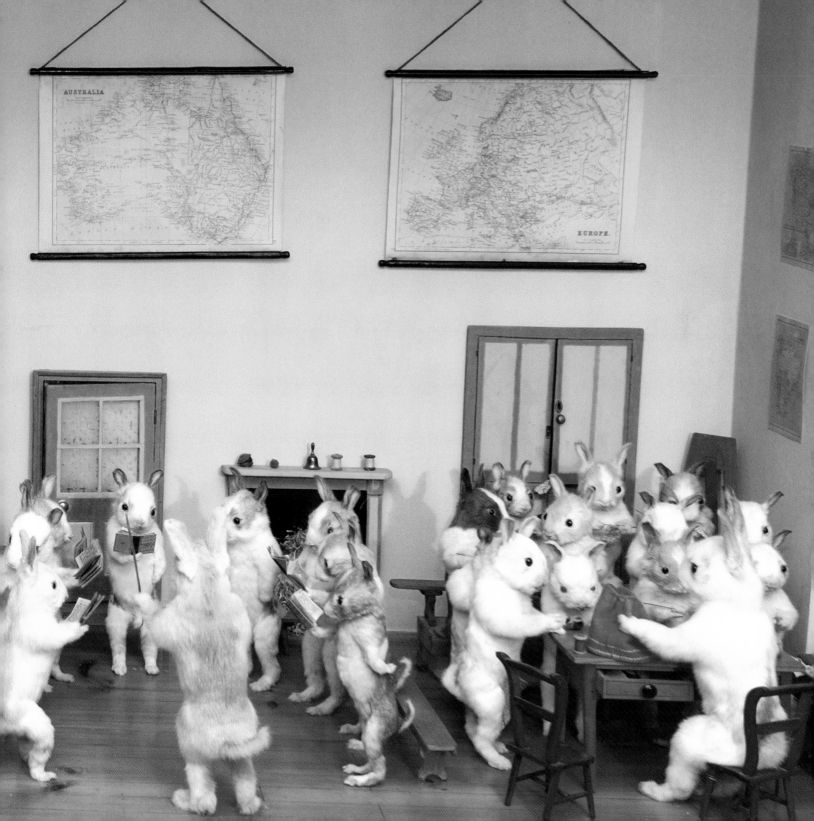

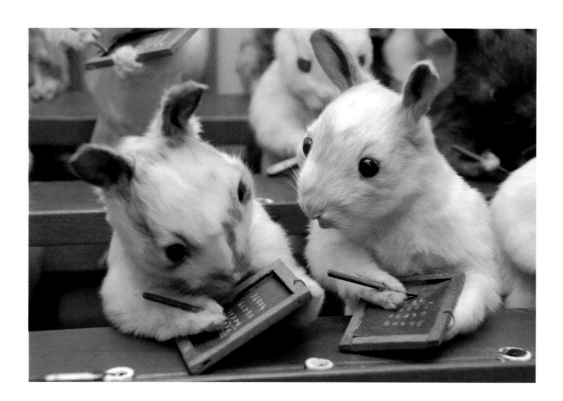

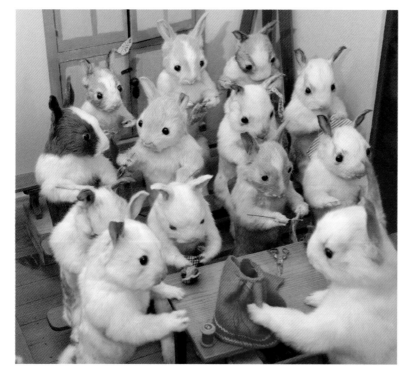
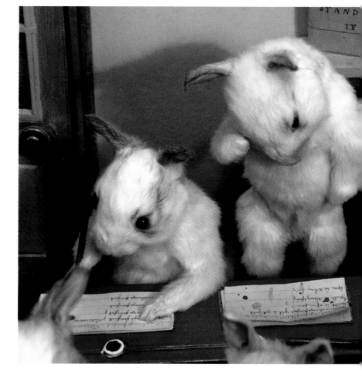

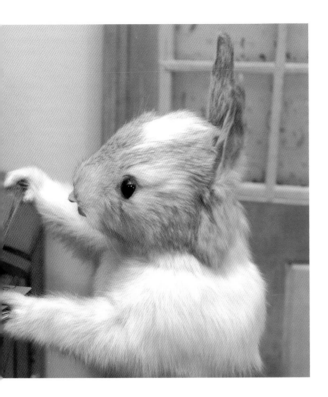

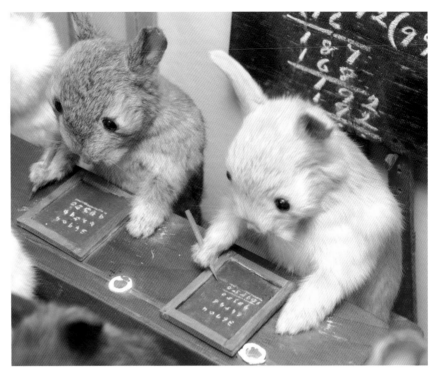

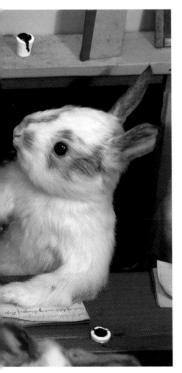

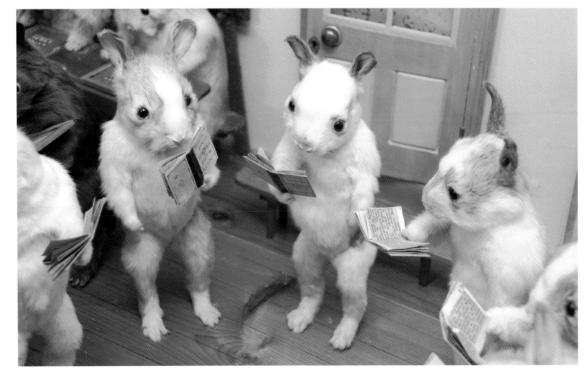

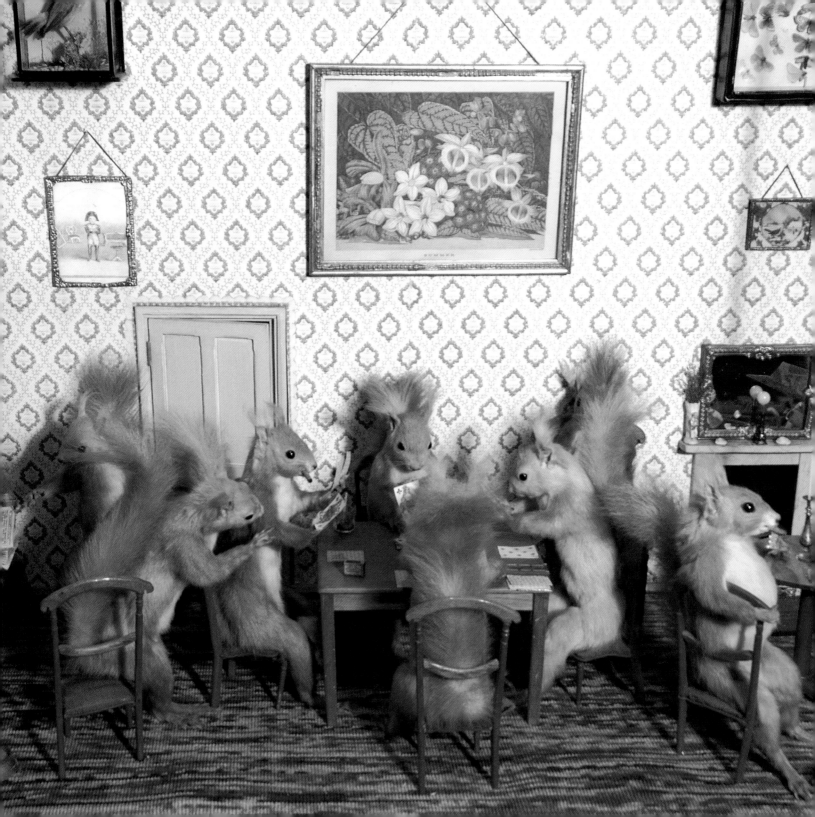

The Upper Ten
Circa 1880
39 x 74 x 21 in (99 x 188 x 53 cm)

Potter went on make other large tableaux two metres wide and nearly a metre high, including *The Upper Ten* squirrels' club and later *The Lower Five*, a rats' den (the titles of these scenes were taken from a popular song of the day). These tableaux were keenly observed social commentaries with a clear class distinction between the two scenes and their animal occupants. The eighteen toffs in the squirrels' club, some with expanded waistlines, had a servant bringing champagne and drinks on a tray and a junior offering a packet of nuts to his lordly superiors. There are cases of stuffed birds on the wall and a spittoon on the floor. Two club members are engaged in a quiet game of cribbage. Another pair are in earnest discussion as to whether to play the Queen of Diamonds at the card table, unaware that the squirrel opposite holds the Jack and the King.

Other club members endlessly dispute some matter of the day over a decanter of port. One, hand on hip and with a foot on the chair, conducts an animated exchange with another who is tapping the table with his fingertips and dropping ash from his cigar. Potter added these two characters after he had seen a newspaper picture depicting men in similar attitudes. The animals are all crudely stuffed, with no modelling under the skin to assist in creating details of expression. Yet these squirrels manage to convey a real sense of engagement and achieve extraordinary renditions of human behavior through their minutely observed postures. As with other cases, red squirrels are shown because this was the 'common squirrel' in Potter's day, and many were shot as destructive pests by local foresters and gamekeepers.

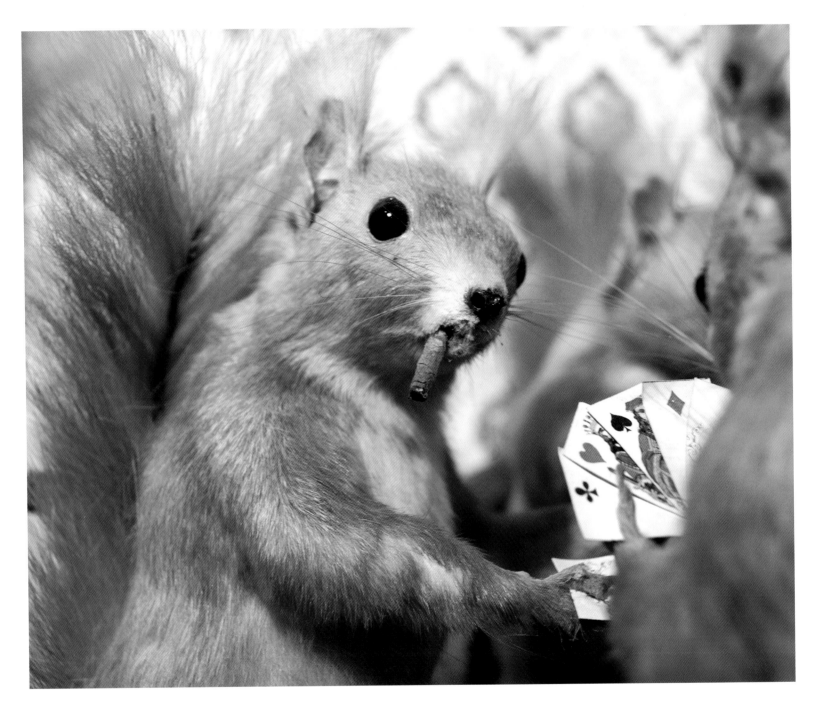

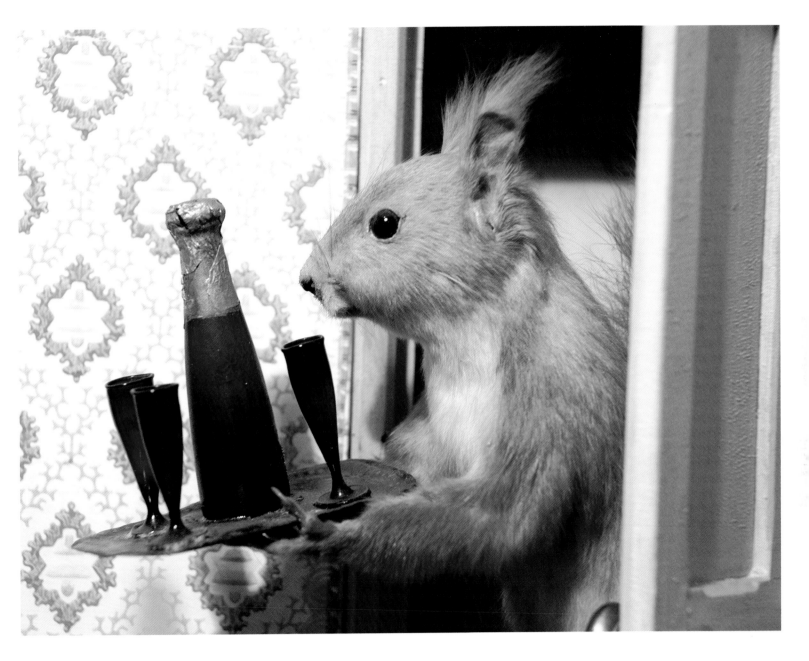

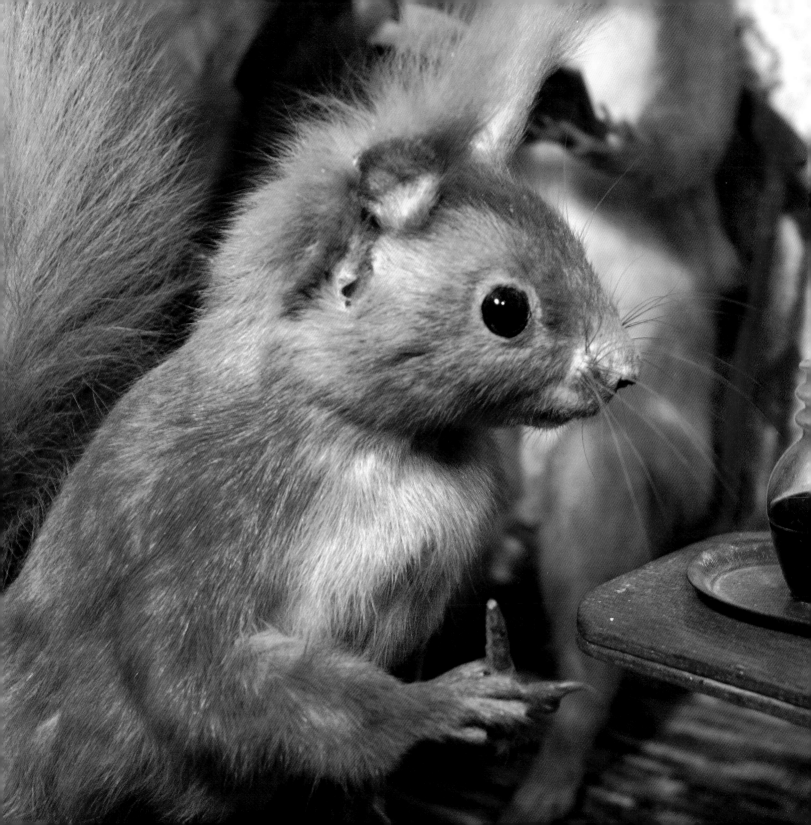

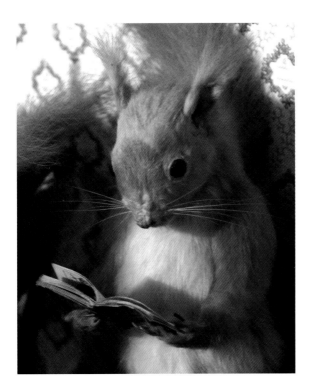
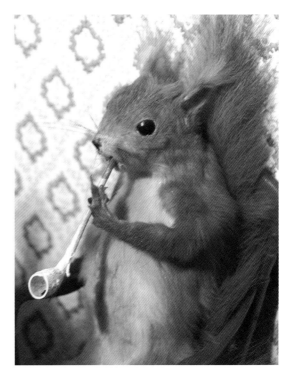
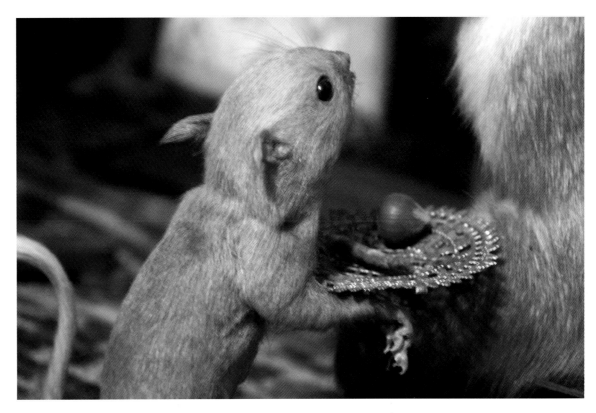

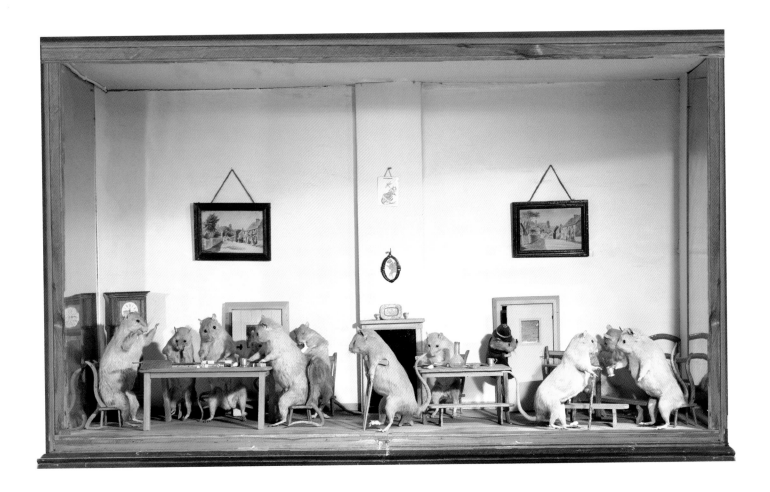

The Lower Five

Late Nineteenth Century

33 x 55 x 17 in (84 x 140 x 43 cm)

In contrast to the squirrels' club, *The Lower Five* was a rather scruffy rats' den. It is depicted as being raided by the local policemen, who see money on the table, clear evidence of wicked gambling over a game of dominoes. One player is obviously protesting at the way the game has gone, probably because his opponent has just laid the double six to claim the game in triumph. Among the fifteen rats, an injured one hobbles across the room, perhaps only recently escaped from a trap or a fight, and some of his associates appear to have drunk too much. One of the rats is puzzling over what seems to be a set of instructions for filling in a census form. This might have been in Potter's mind as once he became head of the family he was responsible for completing census returns every ten years from 1861 onwards. He may well have found that tiresome and the baffled rat represents a fellow sufferer. Other rats are reading or arguing with each other or simply asleep. There seems to be a bit of a brawl going on in the right hand corner, attracting attention from the policeman at the door, although a tiny reassuring notice on the bench reads 'I've never seen that constable run a man in.'

Potter made the necessary furniture from empty cigar boxes and the tiny pictures he hung on the wall show old views of Bramber in spring and autumn. The rats in this den were caught locally for Potter by Spot, a friend's dog, when corn ricks were being dismantled at threshing time. They appear to have had their faces flattened somewhat, to give them a more human expression, with eyes facing more forwards than out to the sides. This tends to eliminate the sinister pointed-nose appearance of living rats that people so dislike.

A player lays a double-six domino to win the game.

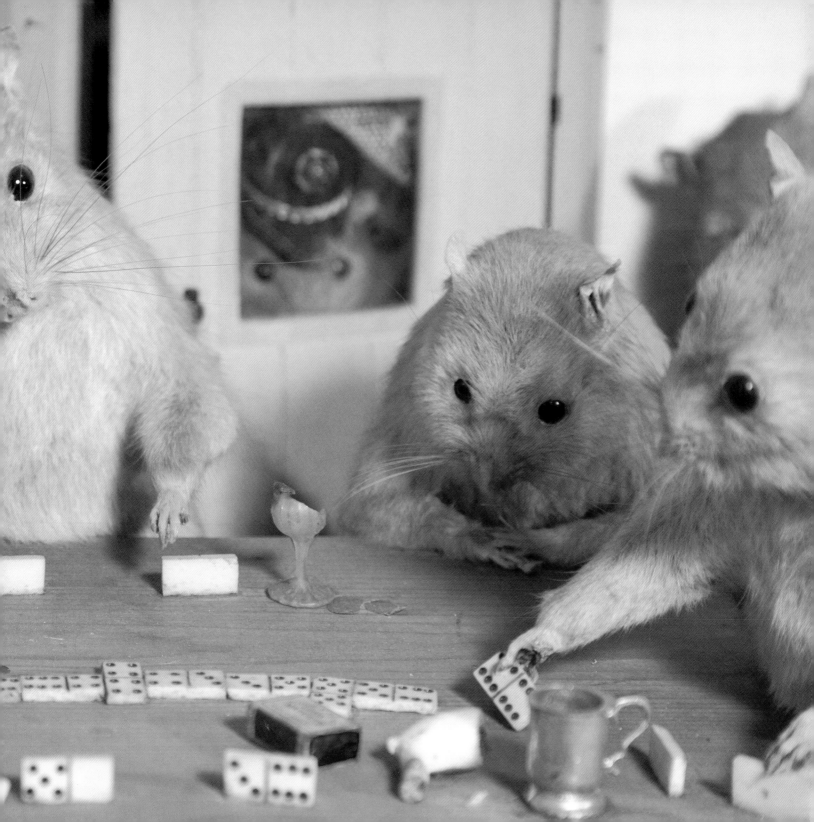

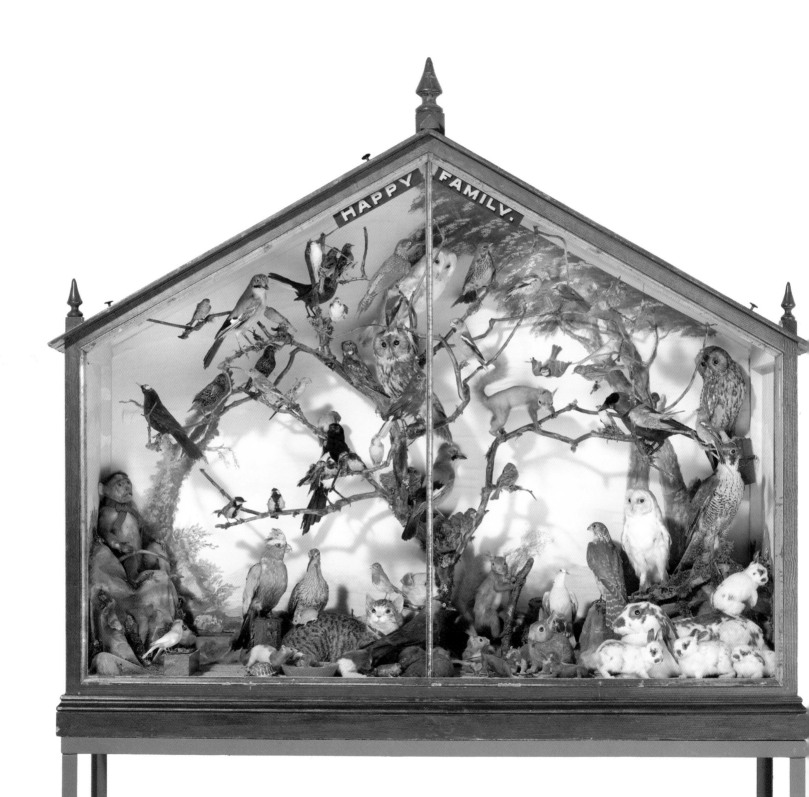

The Happy Family
Circa 1870
67 x 78 x 27 in (170 x 199 x 68 cm)

The Happy Family case incorporated a wide variety of improbably associated animals. This reflects a Christian theme popular in Victorian zoos and menageries, where predators and their various prey were portrayed living together in harmony (one of the best-known examples of this in art is Edward Hicks's *The Peaceable Kingdom*, 1826). Here the cat lies beside a dog with a robin perched on its head, while rabbits play in front of a stoat, mice frolic under the gaze of owls and falcons peacefully cohabit with small passerines. The idea was to suggest that Nature was not always 'red in tooth and claw', but could also be gentle and friendly, a comforting reassurance (to children especially) that animals are nice creatures, just as in the story books that inspired much of Walter Potter's taxidermy. *The Happy Family* case also provided an opportunity to use an assortment of spare taxidermy specimens, including various wild birds, a monkey, canaries and a parrot. A small black rabbit, a tortoise and a toad have also joined this improbably friendly scene.

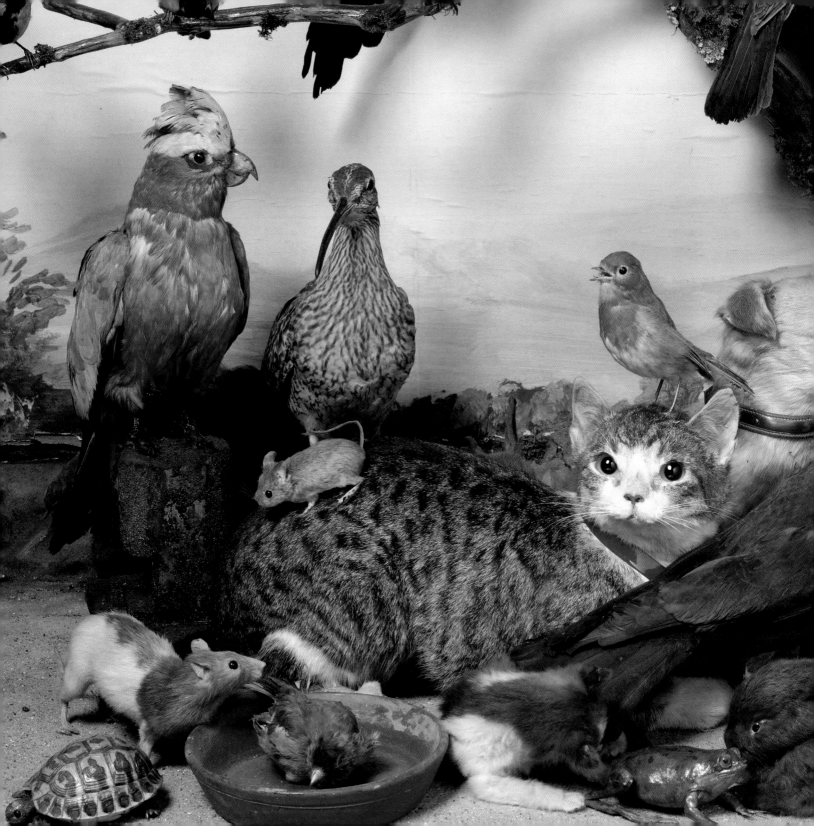

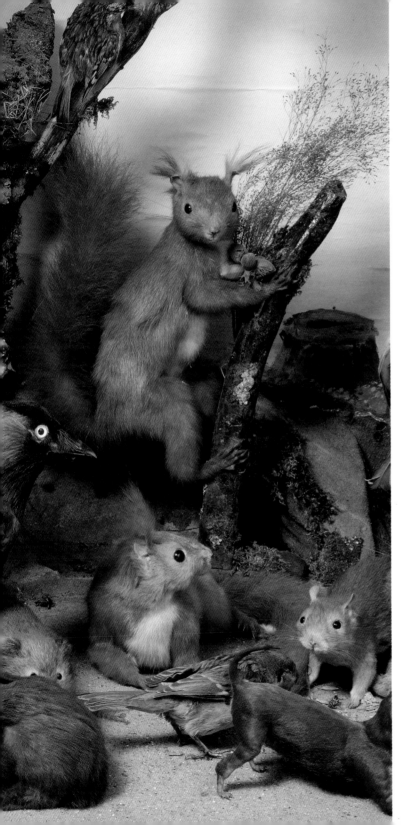

In this improbable assembly, a robin and a mouse sit on a cat, which calmly rests alongside a dog that would normally have given chase to it. A rat playfully tweaks the tail of a small bird. Forest squirrels, a curlew from the moors and an Australian parrot add to this bizarre gathering.

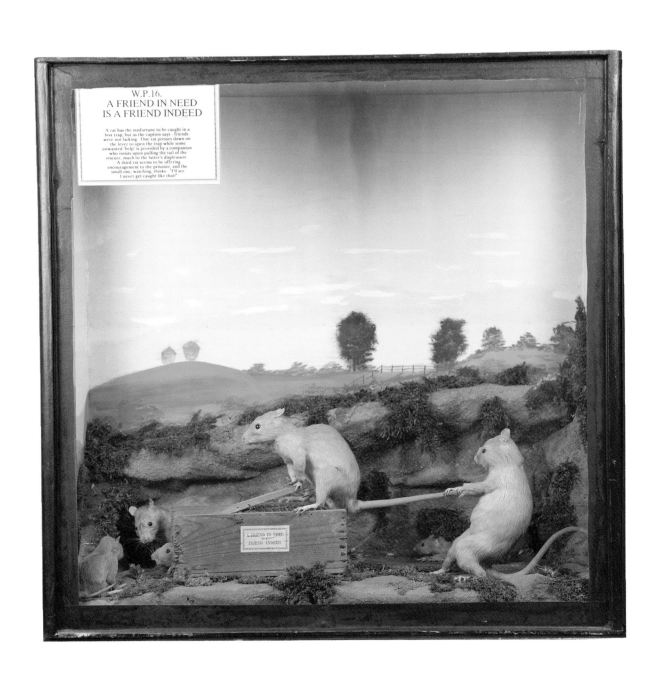

W.P.16.
A FRIEND IN NEED
IS A FRIEND INDEED

A rat has the misfortune to be caught in a
box trap, but as the caption says : friends
were not lacking. One rat presses down on
the lever to open the trap while some
unwanted 'help' is provided by a companion
who insists upon pulling the tail of the
rescuer, much to the latter's displeasure.
A third rat seems to be offering
encouragement to the prisoner, and the
small one, watching, thinks : "I'll see
I never get caught like that!"

A Friend in Need is a Friend Indeed

Late Nineteenth Century

26 x 24 x 13 in (65 x 62 x 33 cm)

One of the smaller tableau cases shows an unfortunate *Friend in Need* caught in a box trap, from which another rat struggles mightily to release it. Other friends try to assist, one pulling unhelpfully on the principal rescuer's tail, while another offers encouragement from a safe distance. A fifth rat watches nervously, perhaps learning to avoid a similar fate; rats are notoriously trap-shy, as Potter must have known all too well.

Another scene depicts several rats trying to steal chicken's eggs. This is an evergreen topic of folklore in the countryside, even today. Potter admitted that he never saw such a thing himself, but created the case based upon what a clergyman (hence a reliable witness) had told him. One rat is seen attempting to carry off an egg tucked under its chin. A second rat rolls another egg from the nest preparatory to carrying it away, while another looks on, perhaps awaiting his turn or maybe having already removed his quota of eggs. Another version of the story, more dramatic but less plausible (and not recreated by Potter), has one rat lying on its back clutching an egg to its chest, while another drags it along by the tail. Potter also set up some rats to illustrate another folk tale, namely that rats will dip their tail into an open bottle of wine or oil and then withdraw it to be licked clean. This representation was described in the Bramber Museum guidebook and shown on one of its old postcards, but the animals now seem to have been lost.

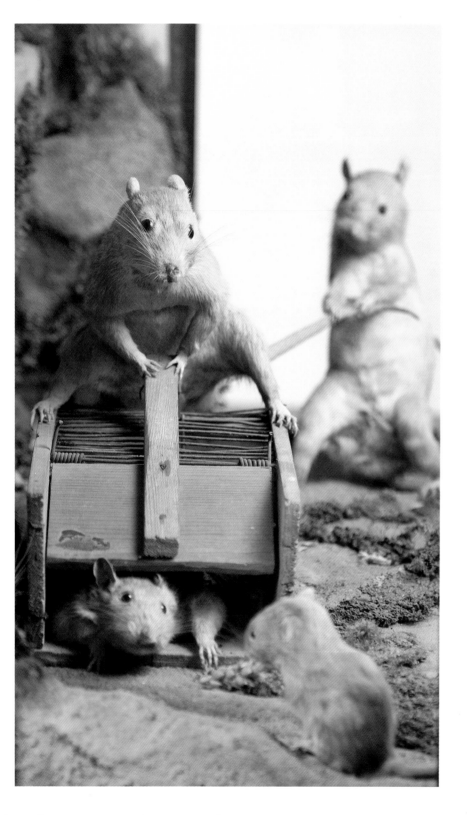
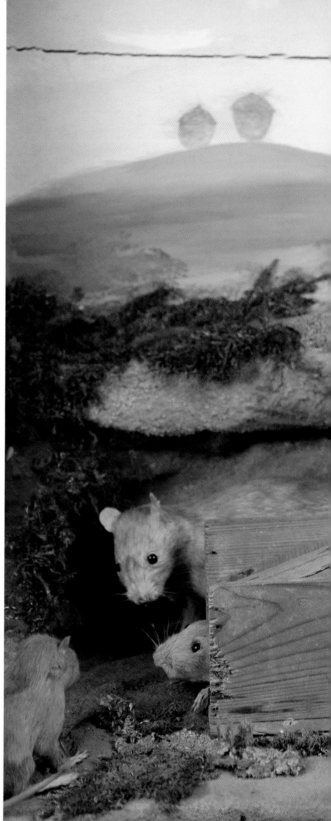

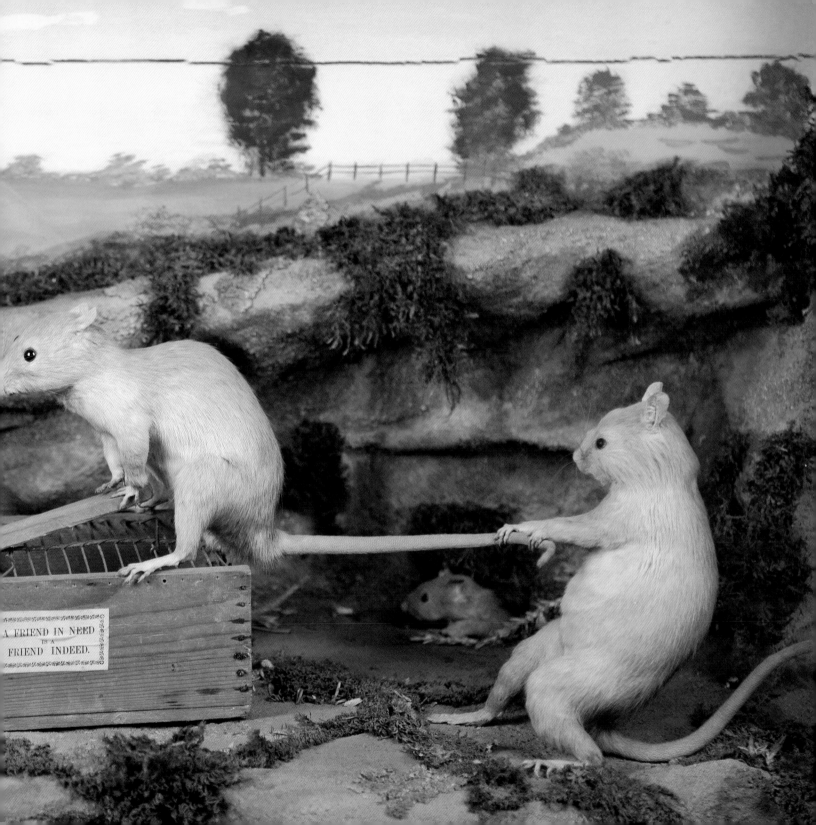

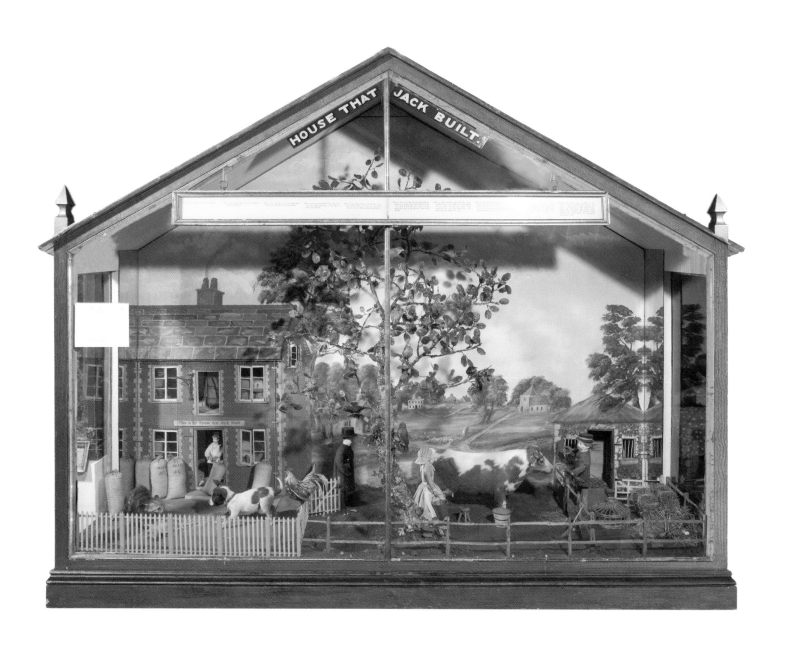

The House That Jack Built

Late Nineteenth Century

76 x 26 x 65 in (193 x 66 x 140 cm)

> *This is the cock that crowed in the morn, that waked the priest all shaven and shorn, that married the man all tattered and torn, the kissed the maiden all forlorn, that milked the cow with the crumpled horn, that tossed the dog, that worried the cat, that killed the rat, that ate the malt that lay in the house that Jack built.*

In *The House That Jack Built*, Potter tried to depict all the characters in the popular nursery rhyme. The building was modelled on a local mill and a sheaf of bills hangs inside the window of the malt house (in which grain was allowed to partially germinate before being made into beer). Some grain spills from a leaking sack by the hoist, all ready for the rat to eat it, as the poem says.

The miniature cockerel was made by gluing feathers to a small model and the cow was a soft toy that Potter purchased and stretched calfskin over, using glass eyes to replace the original buttons. The horns were formed from the tips of real ones. The tiny eggs in the farmyard chicken's nest are actually those of a wren.

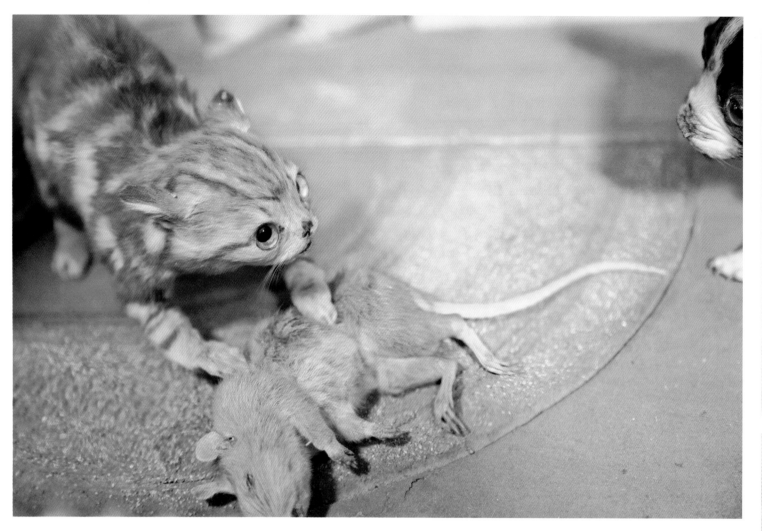

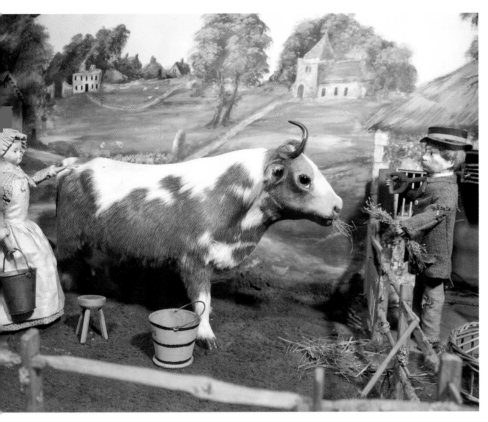

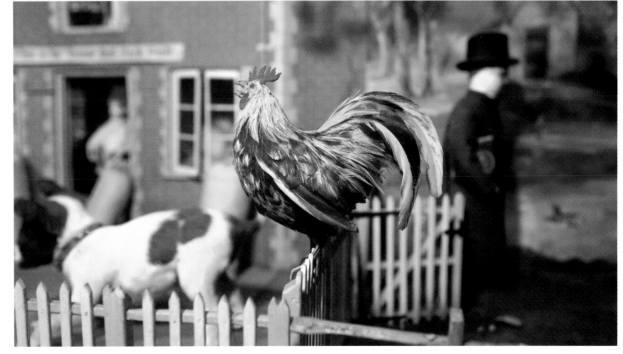

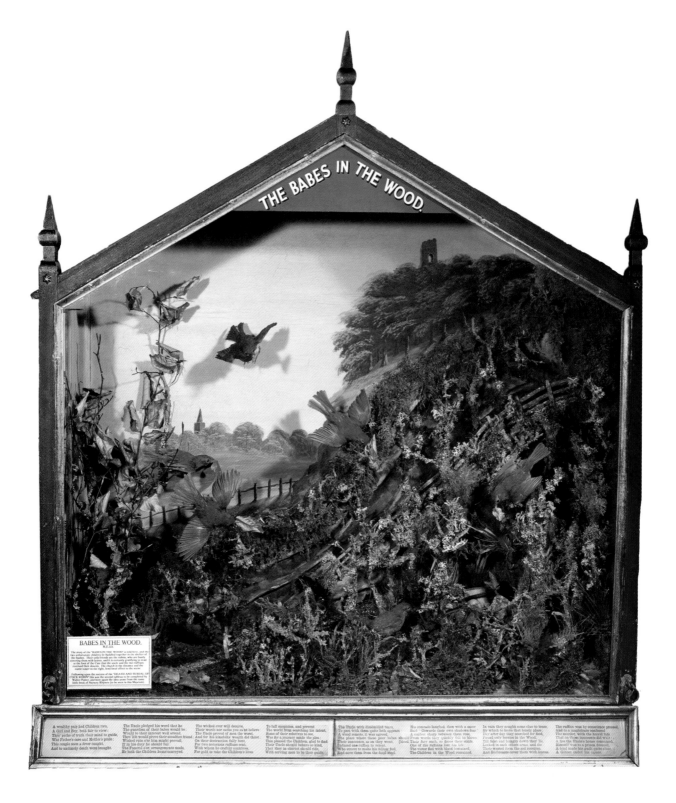

THE BABES IN THE WOOD.

BABES IN THE WOOD.

The story of the "BABES IN THE WOOD" is told here, and the two unfortunate children lie huddled together in the shelter of the bushes. Their only friends are the robins, who are busily covering them with leaves, and it is tremely pathetic to read at the foot of the Case that the uncle and the two ruffians reached their death. The church in the distance and the castle tower to the right, lend local effect to the scene.

Following upon the success of the "DEATH AND BURIAL OF COCK ROBIN" this was the second tableau to be completed by Walter Potter, and here again the idea arose from the same little book of Nursery Rhymes (to be seen in this Museum).

A wealthy pair had Children two, The Uncle pledged his word that he The wicked ever will desire, To lull suspicion, and prevent The Uncle with dissembled tears, His comrades laughed, then with a sneer In vain they sought some clue to trace, The ruffian was by conscience pressed,
A Girl and Boy, both fair to view: The guardian of their babes would be: Their words nor oaths you ca'nt believe The world from watching his intent, To part with them quite both agrees Snol' 'Onwards their own windows four' By which to leave that lonely place; And to a magistrate confessed
Thro' paths of truth their mind to guide, Would to their interest well attend, The Uncle proved of men the worst, Some of their relatives to see, A word remote, it was agreed, A contest sharp between them rose, Day after day they searched for food, The murder, with the horrid fate
Was Father's care and Mother's pride: Thro' life would prove their steadfast friend; Was for a journey made the plan, Was for a journey made the plan, The place where these poor babes should From words they quickly fell to blows, Found only berries in the Wood, Of the Uncle's home consumed;
This couple soon a fever caught, Wicked ruin o'er him might prevail, And for his kindred's wealth did thirst Thus pleased the Children, glad to find Their innocence, as as they went, [blood Their fury such, so fierce their strife, Till faint and hungry down they lie, Himself was to a prison doomed,
And to untimely death were brought. If in his duty he should fail: On their destruction fully bent, Their Uncle should behave so kind, Inflamed one ruffian to relent: One of the ruffians lost his life: Locked in each others arms, and die And justice was to guilt quite clear,
 The Funeral o'er, arrangements made, For two notorious ruffians sent, Who strove to make his felling fied, Who strove to make his felling fied, The victor fled with blood besmained, Their wasted form the sad receive, A tried made his guilt quite clear,
 He both the Children home surveyed. With whom he craftily contrives, And save them from the fatal steel. And save them from the fatal steel. The Children in the Wood remained. And Redbreasts cover them with leaves. A Gibbot ended his career.

The Babes in the Wood

Late Nineteenth Century

48 x 43 x 11 in (123 x 109 x 28 cm)

On their destruction fully bent,
For two notorious ruffians sent,
With whom he craftily contrives,
For gold to take the children's lives.

Potter depicted the poignant story of *The Babes in the Wood* in a small tableau. In this rhyme, two children are orphaned of their wealthy parents and placed under their uncle's guardianship. The uncle hires two 'notorious ruffians' to murder the children in order to gain their inheritance. One of the ruffians has a crisis of conscience and kills the other in a scuffle, allowing the children to escape. They forage for food until they grow weak, and lie down to die in one another's embrace. Robins cover their bodies with leaves (behaviour on the part of robins that is enshrined in ancient folklore). The surviving ruffian confesses; the uncle's house is consumed by fire and he is sent to prison and later hanged.

This seems to have been one of Potter's early tableaux, probably only the second one he built. Again it seems to have been inspired by his sister's book of children's stories and nursery rhymes. The scene illustrates a traditional tale first published in 1595.

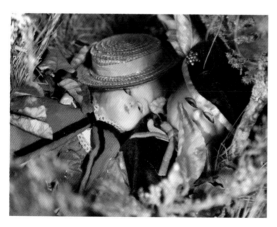 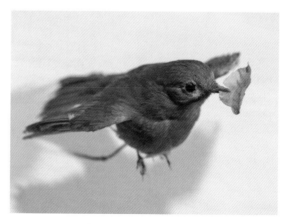

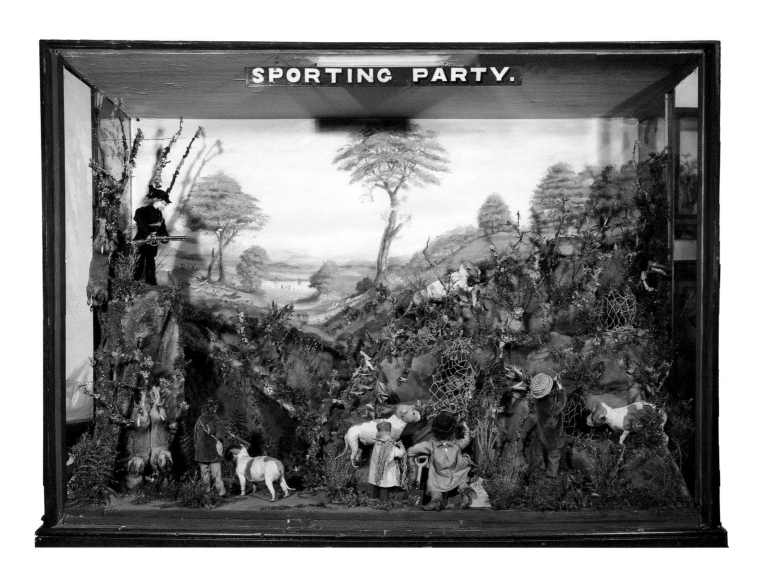

The Sporting Party

1877

38 x 53 x 16 in (97 x 135 x 41 cm)

The Sporting Party was another of the smaller tableaux, being half the size of the principal ones. Five men are seen dressed in smocks and engaged in ferreting for rabbits. In Potter's time, rabbits were very abundant farm pests. Catching them for their furs and to sell for the pot was a profitable full-time job for some and a spare-time pursuit for many. Tame ferrets would be introduced to the warren in order to scare the rabbits and cause them to bolt outside. The men have set nets over some entrances to the warren, but one rabbit is too cautious to come out and be caught. Another scampers away as one of the men raises his gun to shoot it, but the other man cautions him not to fire as this would scare rabbits back down the burrow. Here they would be eaten by the ferret, who would then be disinclined to chase further rabbits out or to emerge back into its owner's grasp. This would have been a common problem for ferreters and well known to Walter Potter who had probably heard many such exasperated tales. Nevertheless, down in one corner the scene shows evidence of some success, with tiny rabbits (actually nestlings) hanging as dead.

The miniature dogs were probably foetuses or small nestlings. Close inspection shows the 'men' to be scarcely more than children, dressed in adult clothes. Perhaps that is why they are facing away from the viewer, coyly concealing their age when they should have been at school, or maybe Potter was simply being lazy and used dressed dolls for the little people in this case. Anyway they seem far too young to be using conspicuously dangerous-looking blunderbusses to shoot their rabbits. One man (kneeling and with raised arm) has the name 'Charles Charman' on his ferret bag, along with the date (1877) when the case was constructed. Charman was a friend of Potter's and owned Spot the dog, who caught the rats used in *The Lower Five* case and whose miniature lookalike stands alert near her tiny master in this tableau, ready to seize any rabbits that might otherwise escape.

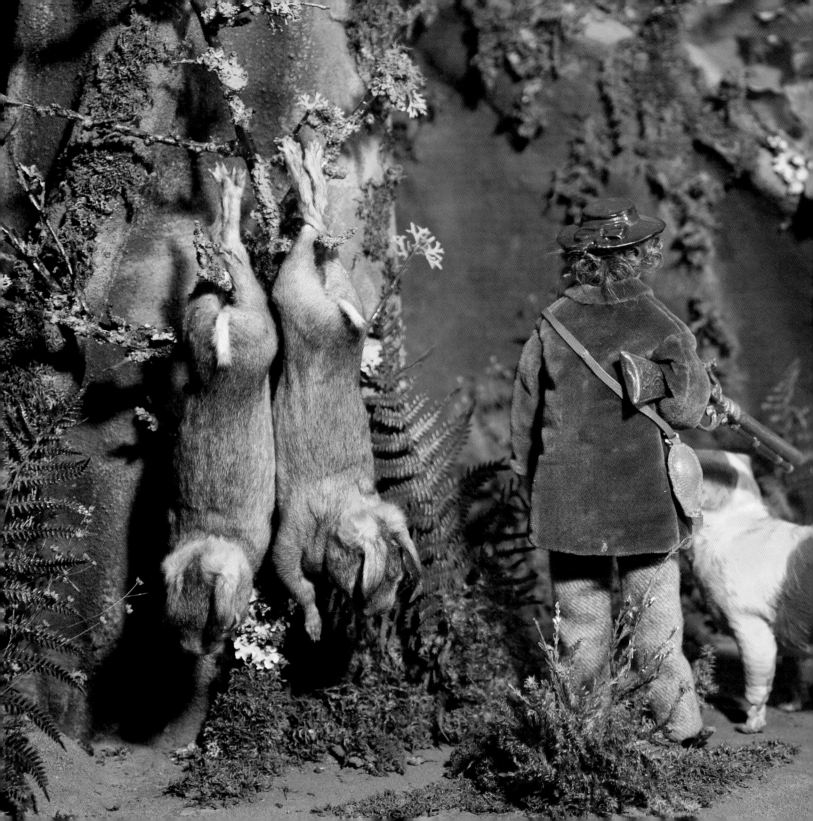

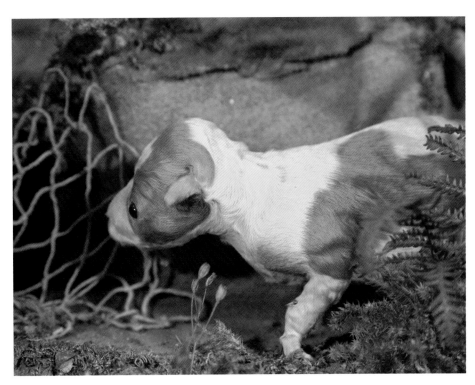
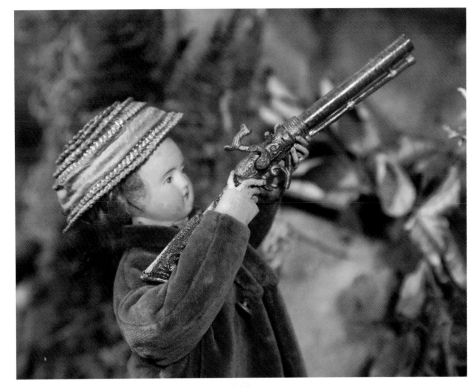

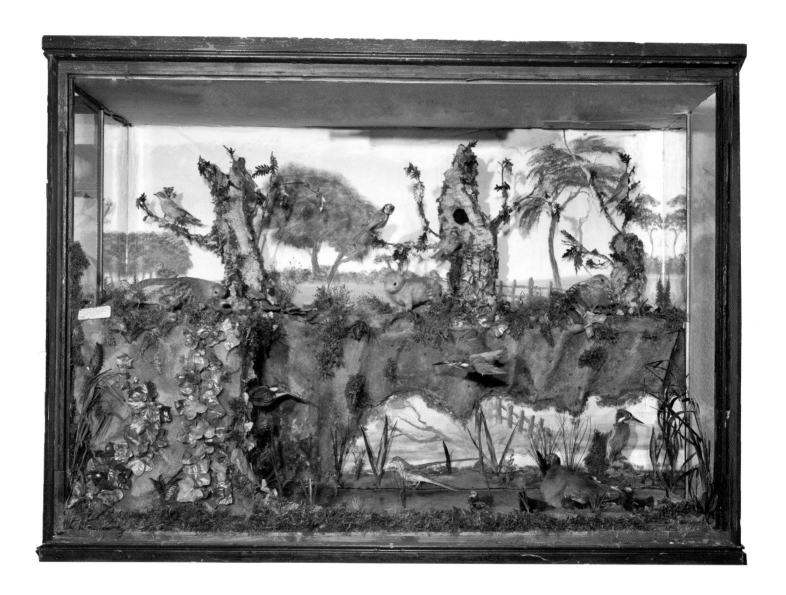

The Kingfisher River Bank

Circa 1878

54 x 40 x 14 in (137 x 102 x 36 cm)

In *The Kingfisher River Bank*, Potter created a large scene around kingfishers that he had found locally. He had watched the birds for a few days and then managed to get the whole nest out of the burrow, along with the seven spherical white eggs. He recreated the scene in one of his glass cases, with part of the artificial bank opened up to reveal the typical underground nesting chamber excavated by the birds. This could be inspected by going round to one side of the case, where a handwritten label says the nest of fish bones and the eggs it contained were taken by Potter in 1878.

The case is richly decorated with artificial ivy leaves and other vegetation, creating further interest and complexity. A moorhen family was added along with a few other appropriate species. Old guidebooks also mention a hidden stoat creeping up on the scared leveret. Although there is now no sign of the stoat, a tiny timid-looking mouse can be seen peeping out from behind the tree trunk. As with Potter's other large cases, there is much intricate detail here and also much to be learned (or shown to the children) with closer inspection.

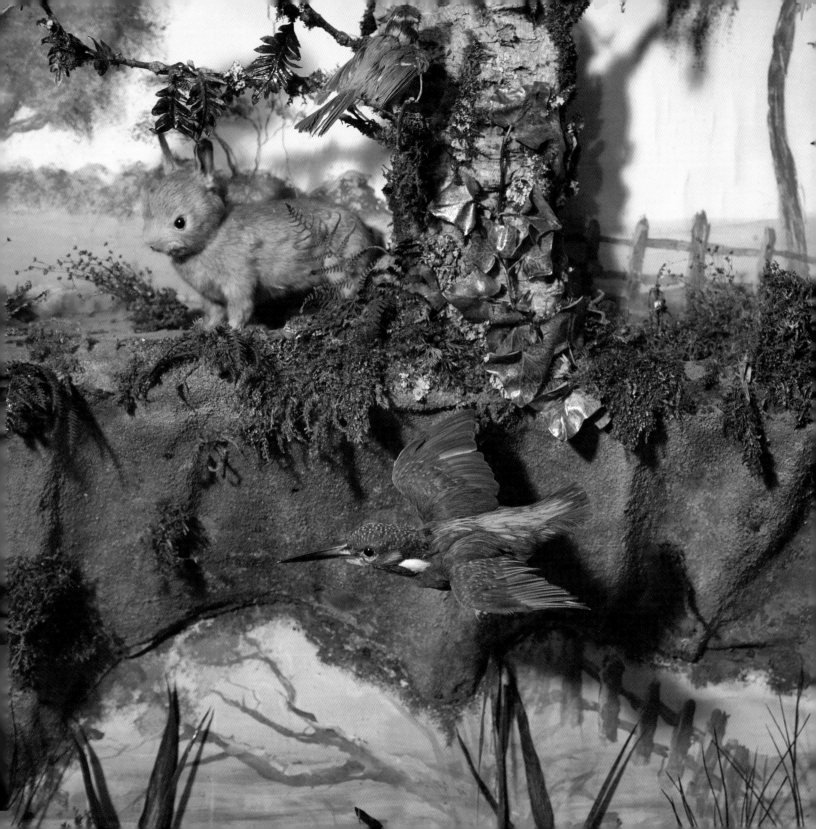

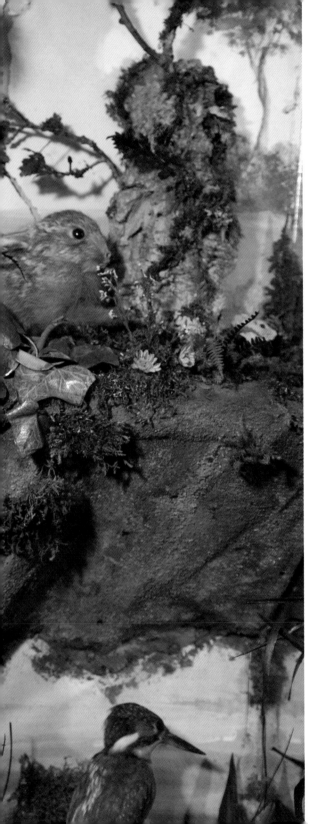
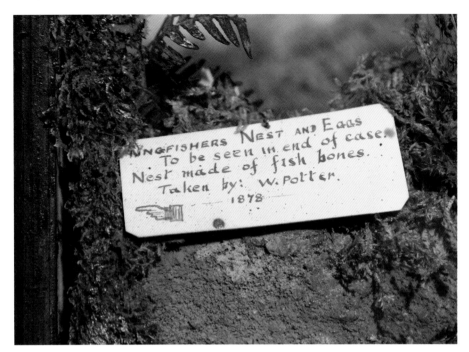

NNGFISHERS Nest and Eggs
To be seen in end of case.
Nest made of fish bones.
Taken by: W. Potter.
1878

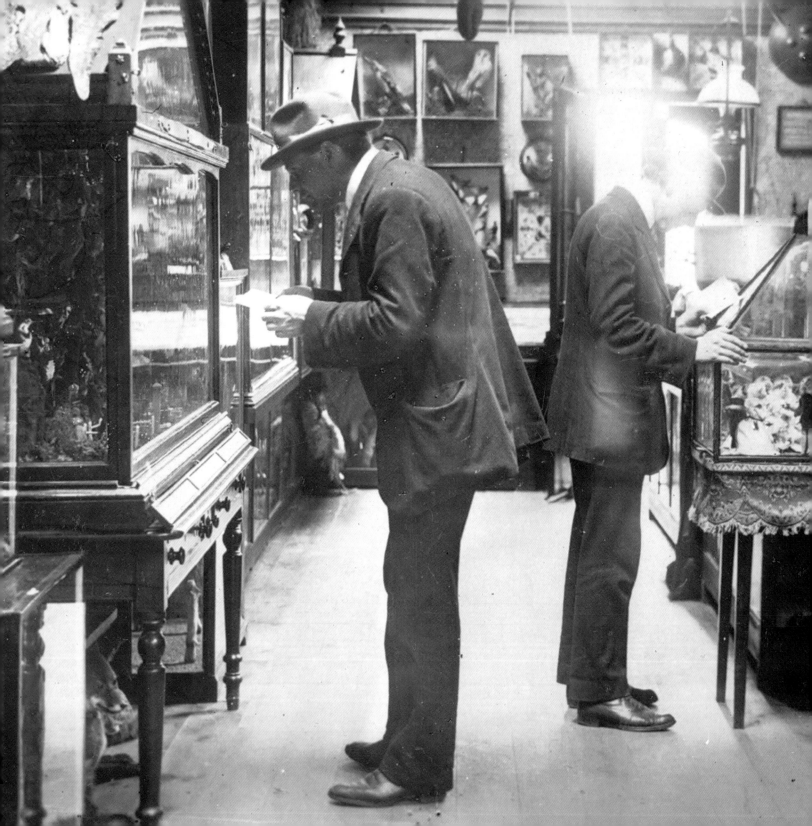

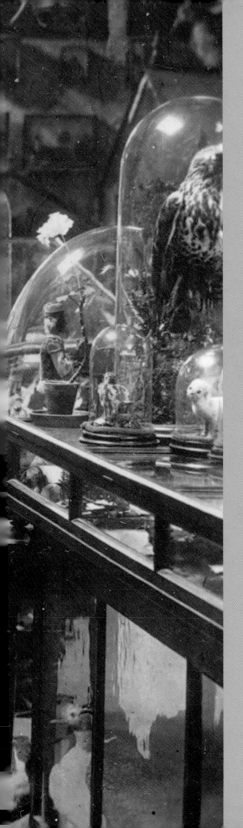

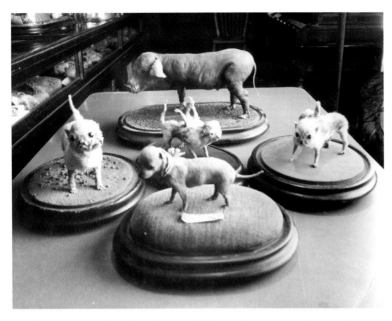

(above, opposite top left and lower right) Generations of press photographers beat a path to the museum's door, particularly encouraged by Eddie Collins. They too were fascinated by the freaks, as this selection shows. Shown here are photographs taken by John Drysdale during a visit to the museum in 1974. The smaller freaks were displayed under glass domes, which were removed for these photographs.

Piglet with three legs and a short life.

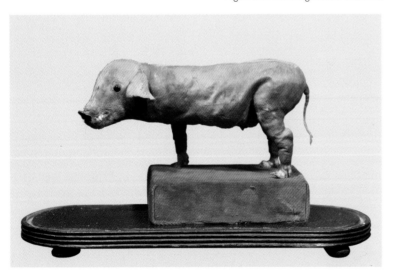

Potter's museum charmed and delighted locals and tourists alike for almost 150 years. Although most famous for its anthropomorphic tableaux, there were several other pieces that captured the popular imagination. One of the favourite items with visitors, and the subject of one of the museum's coloured postcards, was the *Monkey Riding a Goat*; a vervet monkey rather improbably depicted carrying a riding crop and seated astride a goat. According to the Bramber Museum's guidebook, immortalising Potter's own explanation, both animals had come to an untimely end. The monkey, probably an escaped pet, reportedly died of shock when a bucket of cold water was thrown over him by the owner of a fruit shop that it was raiding in Shoreham. The goat lived in Wiston Park near Bramber, but frequently escaped through the hedge and led his herd out to wreak mischief among the local farms and gardens. He was also a bit belligerent towards people, who no doubt became tired of trying to catch him or control his activities. As a result of his insubordinate behaviour, the goat ended up in a glass case, condemned forever to carry his monkey passenger wherever the latter might decide.

A *Rabbit with Tusks* was highlighted in the old museum guide books and featured on a postcard. Potter's collection also included a case of rats with overgrown incisor teeth. This was a common dental anomaly, seen in rabbits and various rodents in which the incisor teeth grow continuously, compensated by continuous wear. So long as the upper incisors bite against opposing teeth in the lower jaw, mutual wear keeps them all in check. But if the teeth become misaligned, then one or more of them is free to grow without being worn down.

Another prominently-featured exhibit was a *Giant Coypu Rat.* This was shot on the bank of the River Adur about

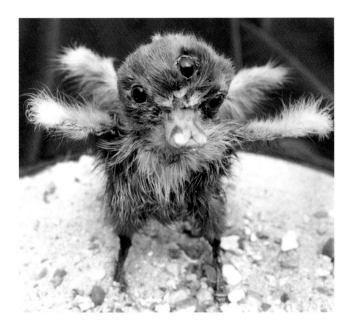

2 km outside Bramber village. It weighed over 8 kg. Coypu originate from South America and were later established in Britain on fur farms and then in the wild (before being finally exterminated in 1987). This one was obtained in 1904, long before the species became well known here and it may have been an escapee from a recently-docked ship downstream in Shoreham Harbour.

The four photographs on the following four pages depict, in order the *Monkey Riding a Goat*; a kitten with two bodies, fused at the head, two tails and six legs underneath with two more on its back from incompletely separated twins (the birth must have been difficult, as, no doubt, was the taxidermy); a seven-legged, two-bodied lamb dated circa 1912 that has been attributed to Potter and appeared in the 2010 Museum of Everything exhibition; and a two headed kitten with four eyes which lived for only seven days (the yellow label was added by Wendy Watts when the collection was housed at Jamaica Inn).

Have your cake and eat it

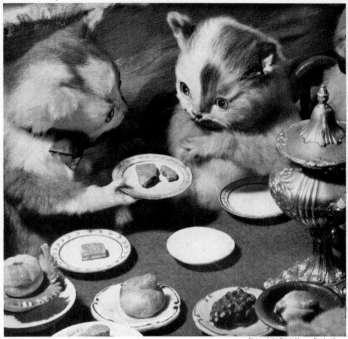

Photographed at Potter's Museum, Bramber, Sussex

Many operators of fleets of vehicles would like to re-equip — but they're frightened of the expense. So they carry on with old and outworn vehicles — heavy in running costs, light in profits.

But with UDT's help you can have your cake and eat it : you can run new, efficient vehicles and let them pay for themselves out of increased earnings instead of capital.

Find out about UDT credit facilities from your dealer or nearest UDT branch — the address is in your local directory.

United Dominions Trust (Commercial) Ltd

UNITED DOMINIONS HOUSE
EASTCHEAP · LONDON EC3

(above) This advertisement for a finance company demonstrates that Potter's anthropomorphic taxidermy has not always been regarded as controversial.

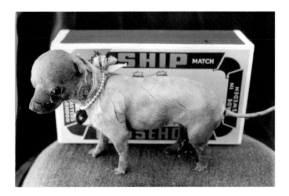

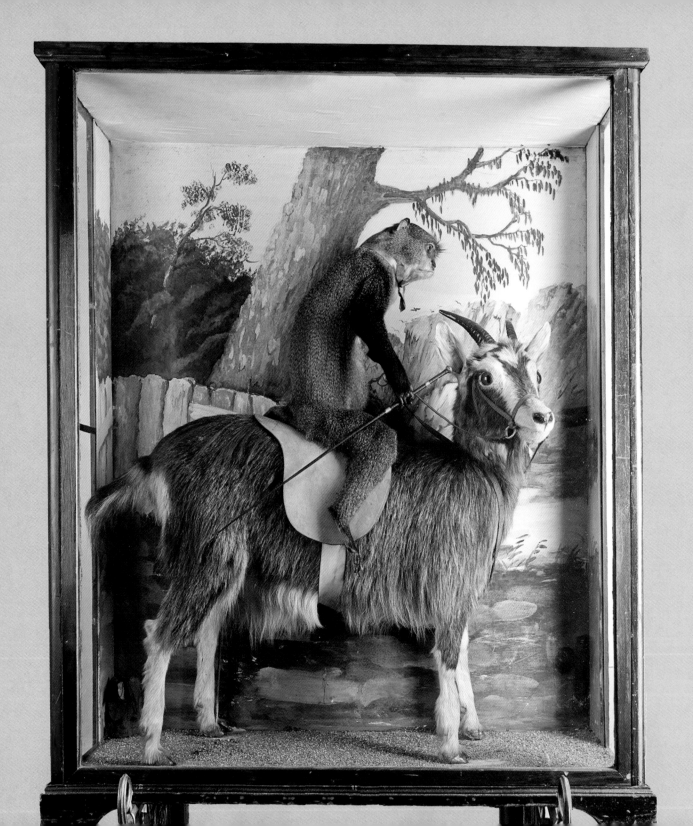

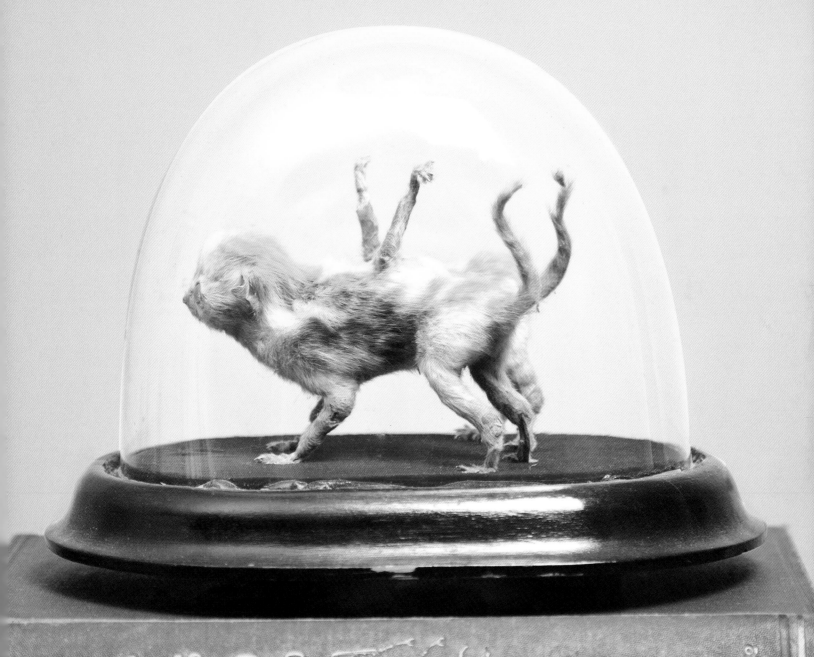

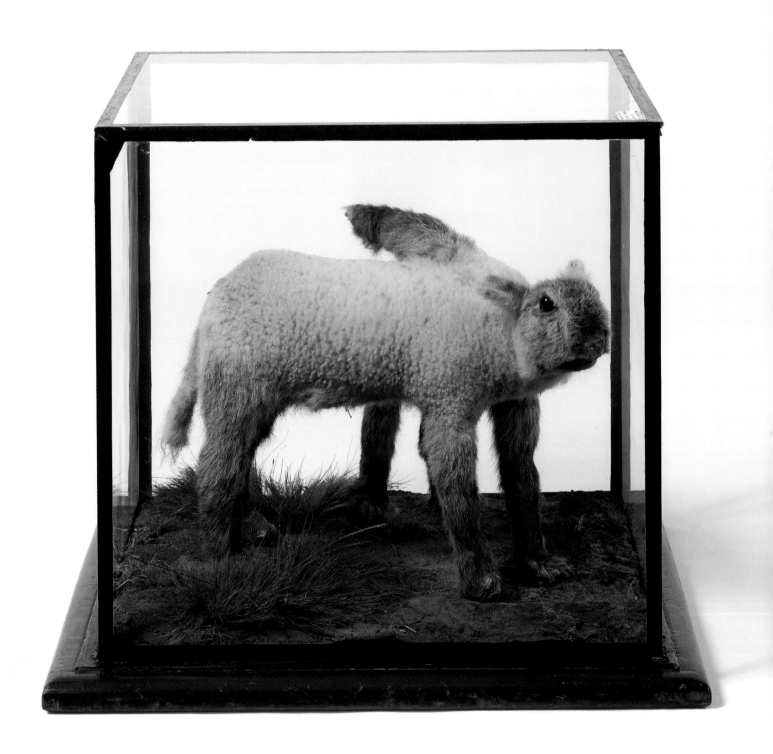

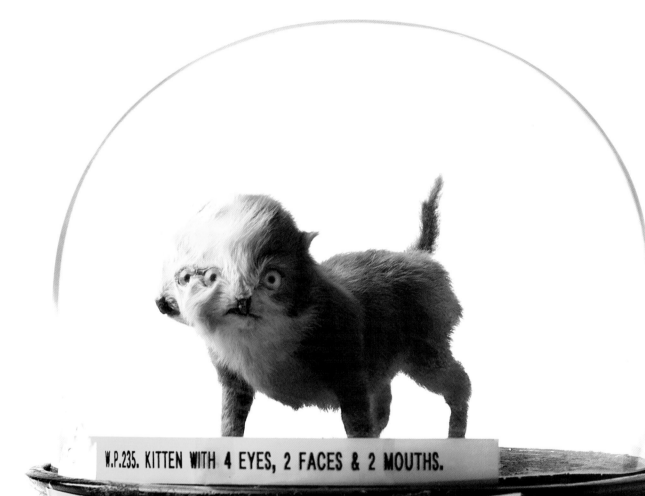

W.P.235. KITTEN WITH 4 EYES, 2 FACES & 2 MOUTHS.

IT WAS BORN AT BROADWATER, WORTHING, & LIVED 7 DAYS

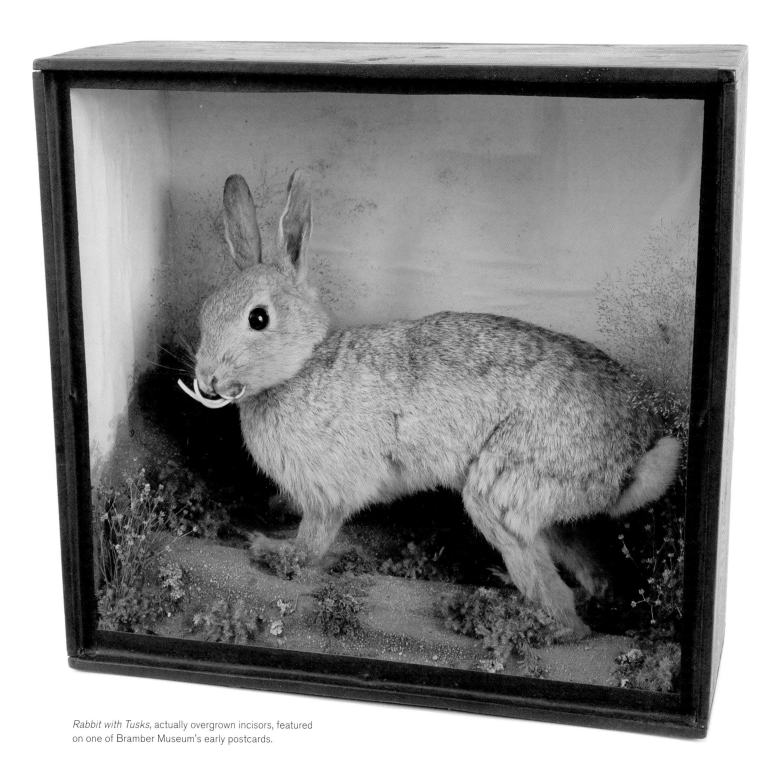

Rabbit with Tusks, actually overgrown incisors, featured
on one of Bramber Museum's early postcards.

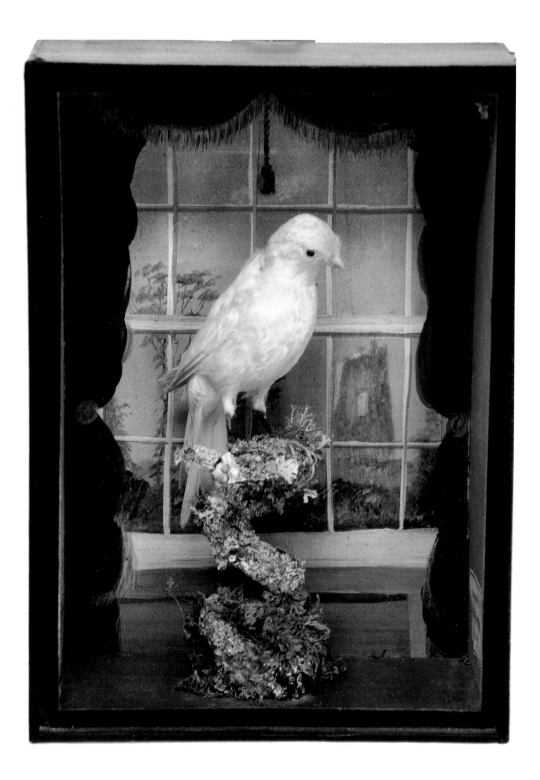

Potter's pet canary, one of his first bird pieces, was mounted in 1854, when he was nineteen years old. The ruins of Bramber Castle can be seen in the background. Walter Potter's trade label can be seen in the right-hand corner.

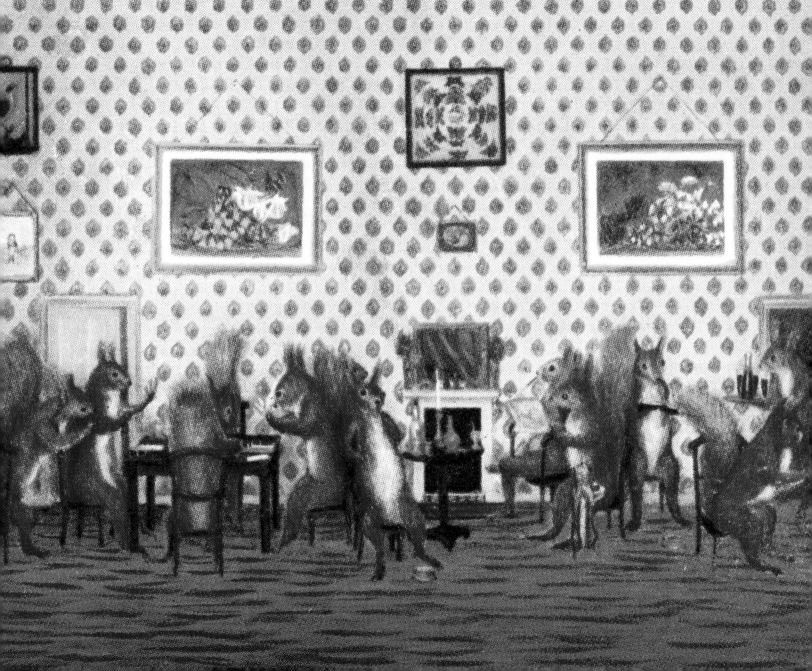

THE UPPER TEN.

EPHEMERA

POSTCARDS

GUIDE BOOKS

MAGIC LANTERN SLIDES

PHOTOGRAPHS

ADVERTISEMENTS

MISCELLANEA

Sketch of Bramber Museum's cluttered interior taken from an old guide book, showing *The Kittens' Tea & Croquet Party* to the right, plunging albatross at top left, and freaks in domes in the foreground. The sloping top of *The Kittens' Wedding* case is just visible to the left of centre, being closely inspected. Potter's portrait is depicted to the left of the bull's horns on the roofbeam.

(right) An assortment of souvenir guides and museum signage relating to Potter's museums over the years.

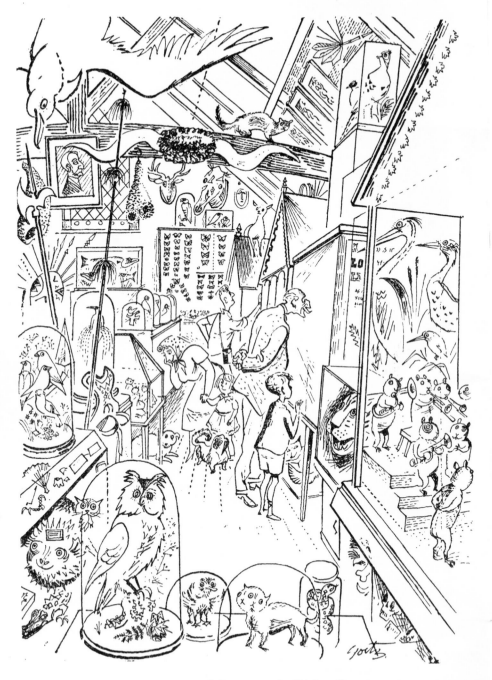

An impression of the interior by Walter Goetz.

Guide Book
and History
of
Potter's Museum
and Exhibition
Bramber, Sussex.

Price 6d.

E. W. COLLINS,
Custodian.

The Museum is four minutes walk from the Ruins
of the Castle and Bramber Railway Station.
Service 22 Southdown Buses stop at the Gate.
DISTANCES.
Brighton 10 miles. Worthing 10 miles.
Shoreham-by-Sea 4 miles. Steyning 1 mile.

Closed on Sundays.

COPYRIGHT. FIFTH EDITION.

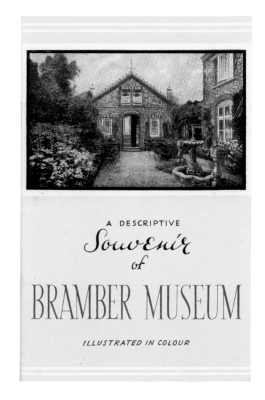

A DESCRIPTIVE
Souvenir
of
BRAMBER MUSEUM

ILLUSTRATED IN COLOUR

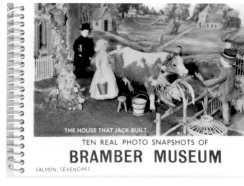

THE HOUSE THAT JACK BUILT
TEN REAL PHOTO SNAPSHOTS OF
BRAMBER MUSEUM
SALMON, SEVENOAKS.

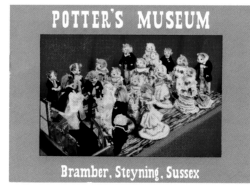

POTTER'S MUSEUM

Bramber, Steyning, Sussex

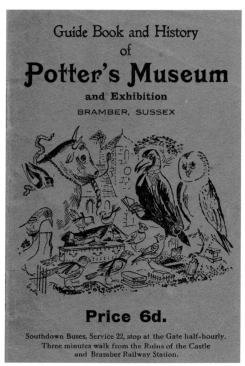

Guide Book and History
of
Potter's Museum
and Exhibition
BRAMBER, SUSSEX

Price 6d.

Southdown Buses, Service 22, stop at the Gate half-hourly.
Three minutes walk from the Ruins of the Castle
and Bramber Railway Station.

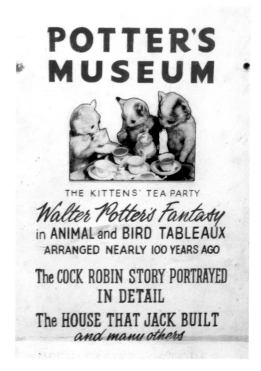

POTTER'S
MUSEUM

THE KITTENS' TEA PARTY
Walter Potter's Fantasy
in ANIMAL and BIRD TABLEAUX
ARRANGED NEARLY 100 YEARS AGO

The COCK ROBIN STORY PORTRAYED
IN DETAIL
The HOUSE THAT JACK BUILT
and many others

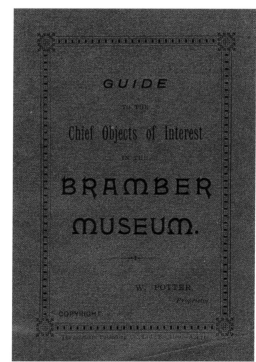

GUIDE
TO THE
Chief Objects of Interest
IN THE
BRAMBER
MUSEUM.

W. POTTER,
Proprietor

COPYRIGHT

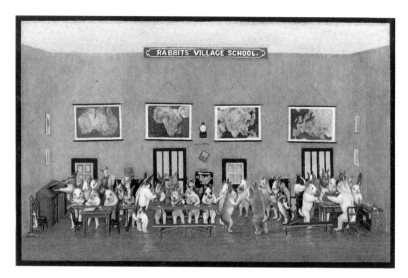

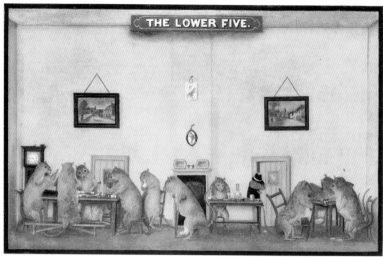

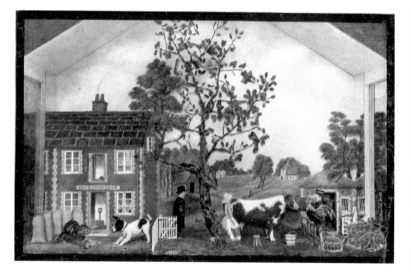

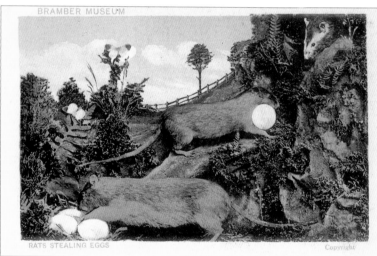

Postcards were an obvious and inexpensive souvenir of a visit
to Potter's museum and large numbers were sold.

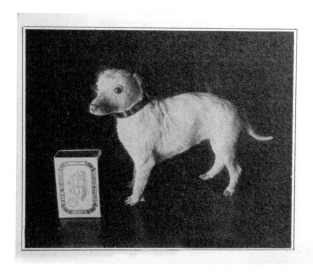

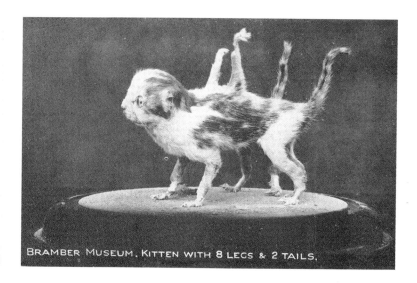

BRAMBER MUSEUM. KITTEN WITH 8 LEGS & 2 TAILS.

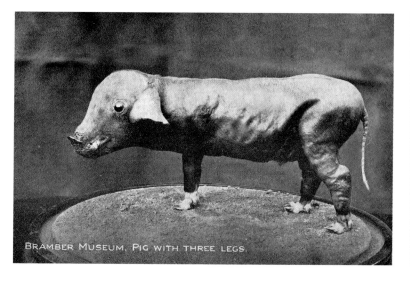

BRAMBER MUSEUM. PIG WITH THREE LEGS.

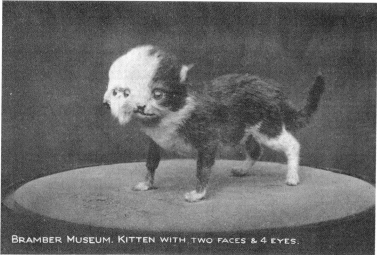

BRAMBER MUSEUM. KITTEN WITH TWO FACES & 4 EYES.

117

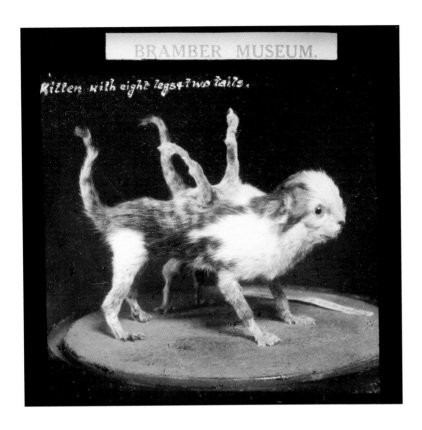

BRAMBER MUSEUM.

Kitten with eight legs & two tails.

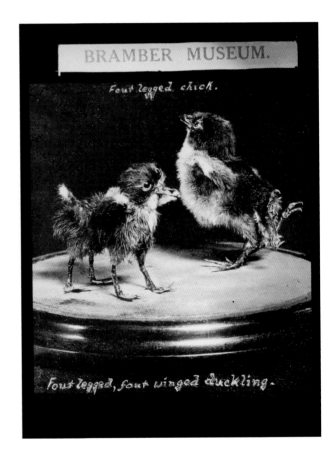

BRAMBER MUSEUM.

Four legged chick.

Four legged, four winged duckling.

BRAMBER MUSEUM.

Flying Fox.

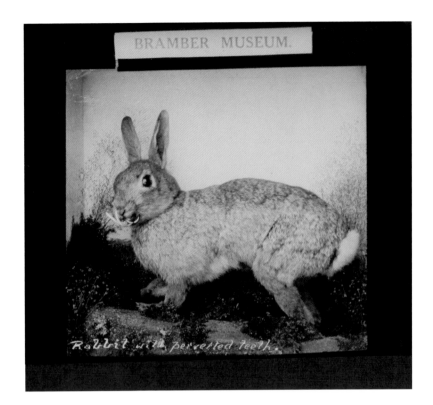

BRAMBER MUSEUM

Rabbit with perverted teeth.

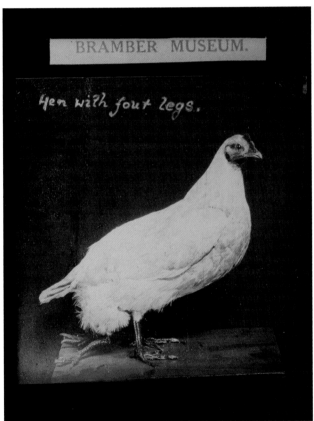

BRAMBER MUSEUM.

Hen with four legs.

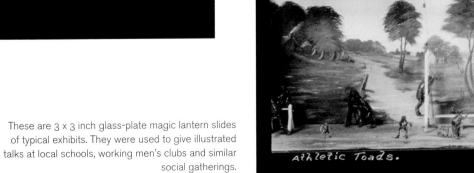

BRAMBER MUSEUM

Athletic Toads.

These are 3 x 3 inch glass-plate magic lantern slides of typical exhibits. They were used to give illustrated talks at local schools, working men's clubs and similar social gatherings.

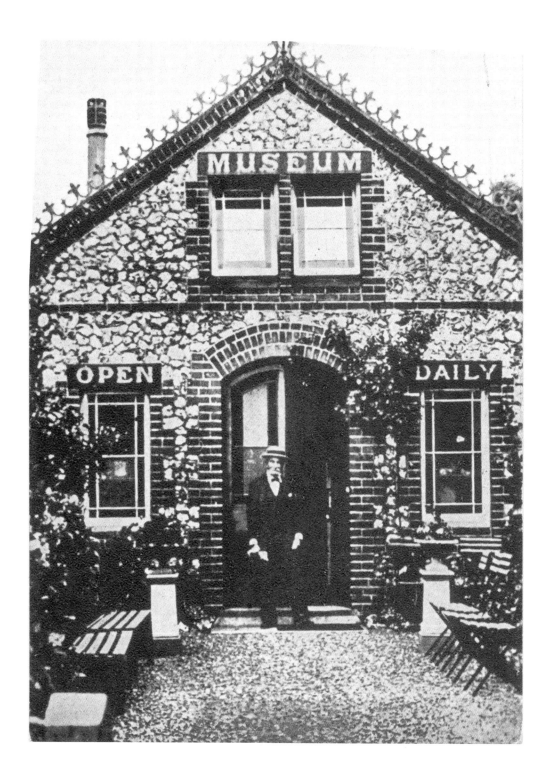

ACKNOWLEDGEMENTS

The author would like to thank John and Wendy Watts for their enormous generosity over many years and for the help that they and James Cartland provided in respect of the earlier edition of this book.

Special thanks also to James Atkins, Jon Baddeley, Laetitia Barbier, Sir Peter Blake, James Brett, Toby Clarkson, James Cranfield, Kate Davies, Robert Devcic, John Drysdale, Errol Fuller, Candice Groot, Charlotte Hanlon, Ben and Lucy Hard, Damien Hirst, Carol and Ron Holzner, Eric Huang, Susan Jeiven, Vadim Kosmos, Lauren Levato, David McComb, Evan Michelson, Jana Miller, Mark Pilkington, Skye Enyeart Rust, Alexis Turner, Cathy Ward, John Whitenight and Frederick LaValley, Viktor Wynd, and Mike Zohn. Particular thanks to J. R. Pepper and G. F. Newland for their help with image corrections.

PHOTOGRAPHY CREDITS

BIOGRAPHIES

DR PAT MORRIS is a professional biologist, formerly Senior Lecturer in Zoology at Royal Holloway, University of London. He specialized in mammal ecology, particularly hedgehogs and dormice, but also travelled widely to more than thirty countries and most of the USA. He has published over 150 scientific papers and magazine articles and some twenty books on natural history topics. His lifelong hobby interest has been in the history and practice of taxidermy, writing nine books on the subject, including *A History of Taxidermy; art, science and bad taste* (MPM Publishing, 2010). He first visited Potter's museum in Bramber as a schoolboy about 1955 and thirty years later became a technical advisor to its owners. With their help, he gained an unrivalled knowledge of Potter's work, first published in 2008 as *Walter Potter and his Museum of Curious Taxidermy*, forming a record of a unique collection now dispersed by its sale in 2003.

JOANNA EBENSTEIN is an artist, designer, events producer and independent scholar based in Brooklyn, New York. Her work revolves around hidden and private collections, and artefacts that fall through the cracks of disciplines or the temper of the times. She runs the Morbid Anatomy blog, dedicated to surveying 'the interstices of art and medicine, death and culture', and the Morbid Anatomy Library, which makes available to the public her collection of art, ephemera, books and curiosities committed to showcasing the places where death and beauty intersect. She also organizes the 'Morbid Anatomy Presents' series of lectures, workshops, and exhibitions around the world; by far the most popular class offered is anthropomorphic taxidermy in the style of Walter Potter. You can find out more at http://morbidanatomy.blogspot.com.

DISCOVER MUCH MORE ABOUT
WALTER POTTER'S CURIOUS WORLD OF TAXIDERMY AT
WWW.WALTERPOTTERTAXIDERMY.COM